GRAND RAPIDS BEER

AN INTOXICATING HISTORY OF RIVER CITY BREWING

PATRICK EVANS

AMERICAN PALATE

Published by American Palate
A Division of The History Press
Charleston, SC 29403
www.historypress.net

Back cover, lower: A group photo of the operation at Veit and Rathman's brewery. *Courtesy Grand Rapids Public Library.*

First published 2015

Manufactured in the United States

ISBN 978.1.62619.558.5

Library of Congress Control Number: 2014953434

CONTENTS

Foreword, by Dave Engbers 5
Preface 9
Acknowledgements 11
Introduction 13

PART I: PRE-PROHIBITION
1. First Brewers 19
2. Christ Brothers 27
3. Brewers of the Late 1800s 29
4. Market Infiltrated 37

PART II. A NEW AGE
5. United Front 43
6. Early Twentieth Century 51
7. Prohibition Hits 54

PART III. POST PROHIBITION
8. First Sips 61
9. Lakeshore Roundup 67

PART IV. PRESENT-DAY BREWERIES
10. GRBC 75
11. The First Wave 77

Contents

12. The Shop That Started It All 82
13. A Brief Hope 85
14. New-Age Founders 88
15. Holland's New Brewery 98
16. European Inspiration 105
17. Sellers Market 112
18. A Second Wave 121
19. Along Chicago Drive 136

Part V: Lakeshore Booms
20. Holland 141
21. Grand Haven 145
22. Muskegon 147

Part VI. Beer, Cider and Spirits, Oh My
23. Ciders 151
24. Distilleries 155

Part VII. Supporting Industries
25. More Than Beer 159

Part VIII: Beer City's Future
26. The Future Is Now 167

Bibliography 169
Index 173
About the Author 176

FOREWORD

B eer doesn't care about your gender, the size of your W2, what you look like, who you pray to or who you're sleeping with. Beer is simply a liquid conduit that has no prejudice and crosses all socioeconomic boundaries, bringing everyone together. It is an even playing field. As long as there are communities full of people, the beer industry will continue to thrive.

In essence, beer is about community and has been since its invention roughly ten thousand years ago somewhere in the Middle East. There are those who have traced the evolution of beer throughout history and made some far-reaching connections who would like to conclude that beer is solely responsible for the agricultural revolution, influential in modern mathematics, the catalyst to the Industrial Revolution and, finally, responsible for all of modern medicine.

While I'm sure beer played a role in each to a lesser degree, I am confident the greatest contribution of beer is its innate ability to bring all people together. There is a reality that beer has, for the most part, always been an affordable social beverage that most people can enjoy. Beer is the choice of the regular stock. It's not pretentious in any way but, rather, highly accessible and pleasing to the masses.

Breweries and brewpubs have always been surrounded with a patronage of assorted characters and strong personalities. These patrons are often referred to as "regulars." I much prefer to lovingly call them "irregular regulars," as these are the folks we've come to know and appreciate on a much deeper level. These are individuals who have become part of Founders Brewing

Co.'s extended family. They are the beer enthusiasts and friends who have supported our portfolio of products throughout our short history. In fact, the name Founders Brewing Co. originated as a nod to our forefathers of the brewing tradition in Grand Rapids. The first labels of our brands celebrated the breweries of years past with a group of brewery workers raising mugs of beer in celebration of our industry.

During our first couple years as a struggling midwestern brewery, it was this local cast of characters who gave us the confidence and the support system that kept our spirits up and helped encourage and inspire our young brewery to persevere and delve headfirst into the path of experimentation and innovation. If this group had abandoned us, surely the face of craft beer would be void of any Breakfast Stouts, Devil Dancers or Dirty Bastards.

We recognized this early on in our existence. When we were still in the developmental and philosophical planning stages of our original taproom, we became hypersensitive to the fact that our beer and taproom would be accessible and comfortable for anyone to enjoy our beer. It was our responsibility to make the best beer that we could and give the beer enthusiasts a great experience in discovering our creations. It was our motto to leave your title at the door; everyone would be treated the same. Surely this communal atmosphere has had a strong hand in developing the personality around our brand.

The communal property of beer surely has been a strong thread in the history of breweries throughout the short history of the United States. Pre-Prohibition, across the country in villages, small towns and major metropolitan cities alike, breweries were simply a part of every community. Before mass transportation and refrigeration, regional breweries dotted the American landscape

In the last forty years, we have experienced one of the greatest evolutions in the history of beer. In true American fashion, the small craft brewers have taken centuries-old traditional beer styles and completely bastardized them. Beer has rarely stayed stagnant. Surely this isn't uncommon, as beer is an agricultural product with brewers using the ingredients that were readily available. In today's global world of mass transportation, information technology paired with the modern industrial and agricultural advances, the breweries are better equipped to make higher-quality, consistent products while educating the consumers to make better choices.

Our consumers are better educated than the beer drinkers of the past, and they have access to information that never before existed. That said, it is our responsibility as a society and community to occasionally take pause,

reflect and acknowledge those who have so graciously paved the road for the brewers of today and of the future. I can only hope that we, too, have an impact on those who will be celebrating our industry for generations to come. Please help us keep the momentum of the craft beer industry healthy by introducing friends to craft beer. It will change their lives.

Cheers,
DAVE ENGBERS
Co-founder, Founders Brewing Co.

PREFACE

When I moved back to Grand Rapids following my graduation from Michigan State University, I was excited that an industry I had grown to love and followed closely in college was growing at a crazy pace. Doing as I am apt to, I began reaching out to the brewers of the region and talking with them in hopes of someday writing a book on the city's budding industry. In a wonderful twist, two of my loves, beer and history, came together when The History Press reached out to me in December 2013 and asked if I would write the history of Grand Rapids beer for the American Palate series.

It's been an amazing experience. For one, writing a book is a humungous endeavor, and the first completed one is a massive learning experience for however many more might come. The project also taught me an amazing amount about my city, from its astounding heritage of an industry many consider damnation to many more related—and not-so-related—parts of Grand Rapids' past.

Most people know the story of today's Beer City, but I've done my best to include as much as I could about the amazing pre-Prohibition days. So many people know Grand Rapids as Furniture City or the city of churches, but for a majority of its existence, Grand Rapids has held a thriving beer community. The current section was written for the future generations of the city, as I wish had been done in the early 1900s.

As the city's drinkers continue to rally around an amazing industry full of people doing great things, discerning palates will continue to force brewers to up their game and attract more breweries with quality product. My hope

is that within a year or two, this book will be out of date because the legacy of brand-new and still-to-come breweries will have grown so much that I will need to do this all over again.

There are chunks of company profiles from the pre-Prohibition breweries, those from the 1990s and the current wave that I wasn't able to fit into the book. Those and future profiles and features will continue to be published in the *Grand Rapids Business Journal*, *Grand Rapids Magazine* and my various other outlets. So stay tuned to the growth the industry has in store for West Michigan.

ACKNOWLEDGEMENTS

A book is a heavy task to take on, as is writing as a career in general. It's not something that's easily left at the office and often takes up hours at home. There are so many people who helped make this book possible. I would like to thank:

First, of course, my parents, Mike and Trudy. Without them, I wouldn't even be here. They've encouraged me to do what I feel is best for me and makes me happy my entire life, and that's an amazing thing in parents.

The rest of my immediate family who have been an amazing support system in my life: Tory, Hillary, Jessica, Holly, James, Matt, Tyson, Jakob, Nicholas, Lindsey, Molly, Avery and Eleanor.

My amazing girlfriend, Alyssa. Every day is made infinitely easier in every way because of her.

Justin Harris, who tried dozens of craft beers with me my junior year of college as we developed our deep appreciation for beer together.

The Mitten Brewing Co., specifically Chris, Max, Jason and Wob, which has given me a home in the craft beer community.

Mrs. Michell and Mrs. Edleman for fostering my love of journalism and writing in high school.

Several Michigan State University professors for helping along my writing and history love.

The *State News* for putting me through a vigorous daily newspaper job while in college.

Bryan and MittenBrew.com for giving me my first opportunity to write about beer on a consistent basis.

Tim at the *Grand Rapids Business Journal* for basically allowing me to create a beat covering the craft beer industry and believing me that it is growing into an economic driving force for Grand Rapids.

Dave, Mike and Jason for being at the helm of the city's two largest breweries and taking the time to regularly chat with me.

The rest of the Grand Rapids breweries for making the city's beer community one of the best and most cohesive in the nation.

The staffs at the Grand Rapids Public Museum and Grand Rapids Public Library for helping with research when I needed it and housing such great archives of information.

The *Grand Rapids Press*, *Grand Rapids Business Journal* and the many other publications that have recorded history in West Michigan.

Tom Dilley for being a welcoming ambassador to the Grand Rapids historical community and providing any help I could need or ask for.

And, of course, Greg Dumais for bringing the opportunity to me and for all his help, along with the rest of the great staff at The History Press.

INTRODUCTION

Among the first beers Canal Street Brewing brewed when it first opened in 1997 was a light pale ale. The beer followed the same formula the brewery used for the rest of its portfolio, a basic style that would appeal to those customers looking to get away from the macro lagers that had dominated America's beer drinkers since Prohibition.

The beer wasn't remarkable, but the label was significant. Co-founder Dave Engbers spent some time prior to opening researching the history of Grand Rapids beer. He discovered there was quite a bit of brewing activity. The brewery, located in the Brass Works Building on Monroe Avenue, was near where several breweries stood pre-Prohibition. With the newfound knowledge of the city's brewing heritage, Canal Street Brewing Co. named its pale ale Founders Pale Ale with an image of nineteenth-century brewers around a giant barrel. The label was meant to pay homage to the city's beer history, but instead, it has helped rewrite it.

The name above the image stuck, and Canal Street Brewing now does business as Founders Brewing Co., the fast-growing, highly renowned cornerstone of the Grand Rapids brewing industry that has come to fame for its beer in the third wave of microbreweries since 2010.

Engbers and partner Mike Stevens had no idea the roller coaster future their company would embark on, but they knew the city's past had some ground to stand on. Now, the Founders pair is leading the charge of a cultural shift in Grand Rapids, and Michigan, as the entire country has seen the desire to consume locally made products—including beer—rise at a rapid pace.

In another century, the names of Dave Engbers, Mike Stevens, Jason Spaulding, Mark Sellers, Steve Siciliano and many others in the Grand Rapids brewing community will be etched in history in far more ways than the likes of John Pannell, Christoph Kusterer, George Brandt, Peter Weirich, Adolph Goetz and the rest of the city's pioneers thanks to technology, but the contributions both groups provided to Grand Rapids are great and often underappreciated.

Prior to Prohibition, Grand Rapids breweries were pushing out hundreds of thousands of barrels of beer every year, well more than the modern breweries were in 2014. Founders appears ready to challenge that though. The massive industry the city was home to prided itself on the quality of the product, pasting "Made in Grand Rapids" on every label. At the end of the nineteenth century and into the early twentieth century, most cities in America were home to at least one brewery. With a lack of adequate transportation and storage technology, beer was best when it was consumed close to where it was made, ensuring freshness. Grand Rapids was a hotbed of German immigration, and along with their suitcases, the transplants also brought their proud brewing heritage across the Atlantic with them. As the city grew, so did the demand for more beer, and the Grand Rapids breweries supplied it. Eventually, the reputation of the city's beers—most notably Grand Rapids Brewing Company's Silver Foam—made its way across the Midwest. The reputation spread, and with increasing technology of storage and transportation, so, too, did the beer. Grand Rapids Brewing Company beer made its way across the country, as far west as Kansas.

Prohibition hit, and Grand Rapids breweries did their best to stay afloat in the time their key product was forbidden from being made. A few did, but not well, and acquisitions and mergers were common. The massive growth of the industrially savvy regional brewers with money and thought behind them—such as Anheuser-Busch, Schlitz Brewing Company, Pabst Brewing Company and later the Miller Brewing Company—grew quickly and took over the nation's beer consumers as a wave of ubiquity took over in everything, from coffee to cola to beer. Americans wanted easy, inexpensive choices. That's what the country rode for more than half a century, and big regional and national breweries were able to use their large home markets of Milwaukee, St. Louis, Detroit, Philadelphia, Pittsburgh, New York and St. Paul, Minnesota, to leapfrog into national prominence or, at the very least, survive the other breweries' takeover of the market.

As big breweries grew, they forced others out of business or absorbed them. Before long, there were only about eighty breweries left in the United States, most producing very similar products.

That takeover of the industry left some consumers wanting. Many of those consumers were travelers and had seen the possibilities the world of beer has to offer. The countries of the Old World still had breweries in every town, many of them having their own take on a style, with beers so different from the ubiquitous light lagers of America because of the ingredients available to them in the area. Some of those travelers returned to America desiring the beers that had quenched their thirst overseas.

Those few started to make beer they wanted. Others tried those new beers and realized what they had been missing, and the dominoes fell in place, leading to bigger, bolder beers that were different than the beers America had grown up with. Breweries such as Sierra Nevada, Anchor Brewing, Sam Adams and Bell's Brewery helped lead into an era of exceptional growth. In the mid- to late 1990s, West Michigan saw an explosion of beer growth, with breweries attempting to brew beers that challenged beer drinkers to try something new and to change their perception of what beer could be. Many brewers failed, however, as most made very similar variations of basic, palate-friendly beers, just different enough from light adjunct lagers. Many went out of business. Others survived just enough to realize they had to do something different. The craft beer movement was helped along by a growing desire for variety and local products. Soon, cities and regions embracing that philosophy grew better "craft cultures," wanting the industries to provide them with fresh products with creative twists. Cities with large, culturally explorative populations, such as Portland, Oregon; Seattle; Denver; Fort Collins, Colorado; San Francisco; and San Diego truly took hold of the movement toward better beer long ago.

In the late 2000s, Grand Rapids saw a rapid increase in pride and a thought process of making local products a priority. With a significant agricultural presence, it was an easy transition for West Michigan to see local products as superior.

Led by world-renowned beer brewpub HopCat and supported by a solid cast of breweries, including one of the fastest-growing and most reputable breweries in the nation in Founders Brewing Co., the community rallied around an effort to be named examiner.com's BeerCity, USA. The poll, created by homebrewing legend Charlie Papazian, was by no means a scientific poll, but it helped some communities realize the beer industry was a welcoming one.

In May 2012, Grand Rapids tied the reigning BeerCity, USA: Asheville, North Carolina. In 2013, Grand Rapids beat Asheville outright, taking 27,005 votes out of a total 50,000. Grand Rapids might not have the sheer numbers of

breweries of Portland or the quality of San Diego, but it does have a community that can rally around an industry and collaborate like no other. Following the BeerCity poll results, San Diego's Stone Brewing Company owner Greg Koch said in an interview that San Diego might have more breweries, but he was envious of Grand Rapids' culture of collaboration.

Papazian put an end to the poll in 2014, explaining that the poll had done its job by bringing awareness to the nation that craft beer was an industry here to stay. Beer has been accepted as a significant industry in Grand Rapids, one that will provide entertainment, jobs and community support for years to come. The city has accepted the challenge to truly become one of the premier beer cities in America, as HopCat continues to receive international recognition, Founders continues to grow, Siciliano's Market provides a backbone to homebrewers and drinkers and new breweries such as Brewery Vivant continue to pop up and create nationally respected beer.

Grand Rapids has once again put itself on the map for an industry, one that has a deep history in the city: beer.

PART I
PRE-PROHIBITION

Chapter 1

FIRST BREWERS

Roughly ten years after Louis Campau built his cabin and several other buildings, and a little more than five years after Campau purchased seventy-two acres of land in 1831 for ninety dollars from the federal government and called the area Grand Rapids, an Englishman found his way to the downtown area.

John Pannell traveled to the River Valley in 1836 with several dozen other settlers, including John Ball. At a time when whiskey was the primary beverage, as it was much easier than beer to transport to a frontier town, Pannell settled into a plot of land at the bottom of Prospect Hill on Bond Street, near present-day Ottawa and Lyon Streets, with the intentions of brewing beer. There, he set up a small brewery, an odd establishment at the time for an Englishman. A majority of early American brewers came from the strong German brewing lineage, and in the near future, Grand Rapids beer would be overrun by Germans, but Pannell was Grand Rapids' brewing pioneer. Pannell, according to Albert Baxter's 1891 *History of the City of Grand Rapids*, made an "English hop beer." These beers were likely meant to be similar to an English pale ale, such as Bass, which was started around this time in England. Pannell's beers, however, also could have been like an early IPA or porter, which also were hoppy at the time. Unfortunately, due to the imperfect scientific technology available at the time, especially on the frontier, Pannell's beers were likely tart, sour and inconsistent. When Pannell opened the brewery, there were fewer than one thousand people in Grand Rapids, according to the 1845 census. Most of the population chose to drink

whiskey, which most merchants sold for twenty-five cents a gallon and served by the tumbler for customers.

At the time, Grand Rapids was far from cosmopolitan, as Ernst B. Fisher noted in his 1918 *Grand Rapids and Kent County, Michigan: Historical Account of Their Progress from First Settlement to the Present Time*: "Naturally it was only the hardy and adventurous who had left comfortable homes to face the hardships of the wilderness."

With the limited consumer base, Pannell's brewery brewed a barrel per batch for the first several years in operation, smaller than most modern startup breweries.

Some records show whiskey as the primary beverage, but Baxter wrote that rum had been the chosen drink for most French and English settlers dating to the sixteenth century, noting that "the article of rum appears [in trading logs] as prominently as pork, gun powders, knives and tobacco." As the city grew, so, too, did the market for beer.

As Pannell built the beer market up in Grand Rapids, a young Christoph Kusterer was building a life in the Black Forest state of Württemberg, Germany. His father, Jacob, owned a large swath of real estate in the area in Gumpelscheuer, where Christoph was born on May 24, 1824. When Christoph Kusterer turned fourteen, he was sent off to Freudenstadt, a town eighteen miles away, to be a brewer's apprentice. He spent seven years learning the brewing trade before returning home at twenty-one and registering for the military draft in accordance with German law. He was passed over in the draft and decided to start anew in America, landing in New

Christoph Kusterer was the second brewer to settle in Grand Rapids and was one of the biggest names in the city until his death in 1880. *Courtesy Grand Rapids Public Museum.*

York in 1845. Once across the ocean, Kusterer found his way to Ann Arbor, an arrangement that had been made before the ocean crossing. In Michigan, he joined the first Ann Arbor commercial brewery, an operation run by a Mr. A. Kern. He spent a few years at Kern's brewery and married Maria Dorothea Dauble in 1847. The pair soon moved to Grand Rapids, with various records dating the arrival anywhere from 1845 to 1848. Kusterer came to Grand Rapids a poor man, but when he died, he was one of the wealthiest Grand Rapids citizens.

According to Baxter, Kusterer began a solo operation in Grand Rapids, west of the Grand River, in 1847. The solo endeavor didn't last long, as he soon entered into a partnership with John Pannell with a capital investment of $800, according to the 1881 *History of Kent County*. At the time, the operation was up to four barrels at a time.

In 1847, when malaria apparently swept across the city, Albert Baxter wrote:

> [C]*hills and shaking ague were terrors of malarially afflicted people and sallow faces and feeble frames were familiar sights. In the eight years following came two experiences—a great growth in the habit of drinking lager beer, and the almost complete dying out of the shaking ague. It is not the province of the historian to moralize upon these facts, nor to attempt an explanation, but only to chronicle the coincidence.*

For some time, between a year and three years, Kusterer and Pannell collaborated and brewed beers together, likely the hopped English ales of Pannell's heritage but probably a tad cleaner due to the German training of Kusterer.

The partnership wasn't meant to be, however, as Pannell was drawn to the calls of riches out west. In 1849, Pannell sold his shares of the brewery to Kusterer and ventured to California to join in the gold rush. Like many, Pannell didn't pan a fortune and ended up back in West Michigan. According to Baxter, Pannell "retired to a quiet life of farming and gardening." Pannell died in 1891, just prior to the publishing of Baxter's book.

Following the sale, Kusterer made changes to the brewery that he must have been itching to make. His first move was to rename the operation City Brewery and move it a few hundred feet north down the road to the corner of East Bridge and Ionia Streets. This location was built on or near a flowing spring, which pushed out nearly forty gallons of water a minute. Historians had written that the well was a gathering place for Native Americans prior to the arrival of settlers, and the water came from deep rock formations that

provided a year-round temperature of fifty-eight degrees. Had there been the demand, or if Kusterer had the capabilities, the water would have been enough to brew more than twenty-one million gallons of beer each year.

The buyout also led to the first lager beer in Grand Rapids, as Kusterer was able to make the beers he was trained to produce. He did everything on his own at the beginning, from brewing to delivery.

In 1855, he built a house just next to the brewery on East Bridge Street, where it stood for more than fifty years. He also continued to invest in other operations, including a hydraulic company and the Star Flouring Mill.

The many German brewers in the city in 1890 told Baxter "it [City Brewery's beer] was not of a quality which they would boast of very much at the present day." Despite the poor quality, early Grand Rapidians had come to appreciate light malt beverages, and something was better than nothing.

"I imagine people wouldn't buy it if it was crap," said William Seeger, a former professor of German heritage at Grand Valley State University and a Grand Rapids beer historian.

The popularity of Kusterer and the great service he provided the city led him to a position of authority within the German immigrant community in Grand Rapids, which was sizable. Many Germans had heard of the growing population and continued to settle in Grand Rapids, and Kusterer capitalized as the sole purveyor of beer in the city. Despite the low quality of his beer, as the only beer producer in town, the Germans took note of Kusterer, likely because he possessed a great sales mentality and charisma, like many other early beer barons. His involvement in the community went far beyond providing beer to drinkers. He helped found the German Evangelical Lutheran Church of Immanuel in 1856. A small church was completed in 1858 on Bridge and Division Streets, overlooking the city. The church outgrew the modest location and upgraded with a $35,000 addition—nearly $1 million in modern dollars—in 1890. Once one of the highest points in Grand Rapids, the church is now vastly overshadowed by the forest of medical buildings that tower over it in the city's Medical Mile.

He was also highly active in the Grand Rapids Rifles, a German American militia team, and served as the grand marshal of a parade celebrating the "Grand German Jollification." The celebration was following the 1871 German victory against France in Europe.

Germans quickly were among the city's largest ethnic groups. For most of Grand Rapids' history, the Germans have been the number two group in population. This large immigration was because of a trend called "chain migration," according to Seeger. The trend would follow a simple process:

first one family member would come over and settle, and before long, siblings, nephews, nieces and cousins would all follow and settle in the same place.

With the large wave of German immigrants came more with brewing expertise and an increased thirst for beer. Along with the Germans came a large Dutch population, which also preferred a light beer and drank plenty of it, although Seeger said they might not like to admit it.

By 1879, Kusterer's operation was a key part of the Grand Rapids community. The *Grand Rapids Times* said in June 1879, "No business house in Grand Rapids is more generally known, patronized or more generally conceded the plan for enterprise, prosperity and substantial progress than the celebrated brewing establishment of Mr. C. Kusterer."

The article went on to state that the brewery was up to an annual capacity of 9,000 barrels. His beer was sent to Ohio and Indiana regularly and sometimes farther. "The fame of Kusterer's beer long since spread beyond the boundaries of our own state, and it now fairly contests honors with the

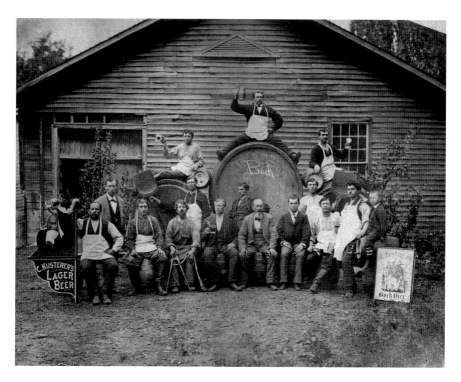

Christoph Kusterer's crew outside of his brewery, taken before his death in 1880. Kusterer is at the center of the picture, with his hands on his knees and wearing a bow tie. *Courtesy Grand Rapids Public Library.*

vaunted Milwaukee and Cincinnati beers at home and in their own markets." At the time, the brewery held 1,350 barrels of beer in its cellars, readying for the market. In the storage of beers, the brewery used more than one ton of ice per day. The company employed thirty men at the time that the article was written.

The beer was so popular in Grand Rapids that five hundred kegs were delivered regularly within the city limits, and Kusterer carried the largest supply of beer in the state. The brewery could store up to seven thousand bushels of barley, allowing Kusterer to purchase it in season to allow for an advantage over competitors.

A sad incident involving Kusterer's company occurred when one of the beer wagons ran over a boy at the corner of Bronson and Canal Streets. The April 12, 1880 *Grand Rapids Daily Leader* said it was first thought the boy was seriously injured, but it turned out he just had a few bruises.

Kusterer's position in the German community continued to grow as beer production increased. In October 1880, Christoph Kusterer was set to head to Chicago on a business trip. He traveled to Grand Haven to board the *Alpena* to take the quick trip on Lake Michigan. The ship departed at about 9:30 p.m. on October 15 and was seen the next morning at 1:00 a.m. by the ship the *Muskegon*. The *Alpena* was also seen several times throughout the morning by a schooner called the *Irish* and the *City of Grand Haven* barge near Kenosha, Wisconsin. Barometers showed storm-like pressure, and sometime in the morning, a storm known as the "Big Blow" moved in and devastated the 197-foot steamer. Some captains reported seeing the ship on its side, leading some to believe the ten loads of apples on the main deck caused unbalance and led to the capsizing.

The *Alpena* drifted back east, and some of the wreck was scattered along the coast near Holland. Both the *Holland City News* and *Saugatuck Commercial Record* newspapers reported pieces of the ship being strewn about the shore, including the piano and thousands of apples. Between sixty and eighty people were lost on the *Alpena*, including Christoph Kusterer.

Kusterer's body was never found, but a memorial lies with the rest of his family at the Oak Hill Cemetery on Hall Street on the south side of Grand Rapids. A small obelisk denotes the family's plot, with his memoriam in German: "*Bei den untergang der Alpena aug Lake Michigan,*" or "In the demise of *Alpena* on Lake Michigan." Kusterer's wife, Maria Dorothea, survived until 1903, and her monument is on the adjacent side of the obelisk.

The 1900 *City of Grand Rapids and Kent County, Mich: Up to Date* said: "No man in the city had been more enterprising than he, and none more

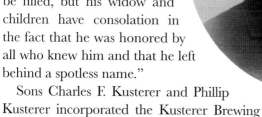

Charles F. Kusterer was a son of Christoph Kusterer, the original beer baron of Grand Rapids. Charles F. Kusterer later served as Grand Rapids Brewing Company's first president. *Courtesy Grand Rapids Public Museum.*

charitable, kind and public spirited. His loss has never been and probably never will be filled, but his widow and children have consolation in the fact that he was honored by all who knew him and that he left behind a spotless name."

Sons Charles F. Kusterer and Phillip Kusterer incorporated the Kusterer Brewing Company in May 1881 with an initial capital investment of more than $100,000. The operations were housed in a large brick building on the corner of Bridge and Ionia Streets, where their father originally set up his operation.

The location was damaged in a fire on November 4 of the same year, causing severe destruction. The fire was found at 2:00 a.m. in the icehouse, which was burned to the ground despite the one thousand tons of ice stored within. As the fire raged, it jumped to the brick malt house next door and ruined one thousand bushels of the malt. The brewhouse and cellared beer remained untouched, but the malt house needed renovation, and a new icehouse was soon built.

According to the day's *Grand Rapids Daily Eagle*, the brewery's operations continued as normal. Mr. Kusterer told the paper the damage of the fire was about $15,000, and insurance would cover roughly $14,000 of the damage.

Once up and running, Kusterer Brewing Company employed thirty men and raked in approximately $97,000 annually by brewing "all the popular varieties of lager beer." The operation was a dominant one in a city whose beer industry was in its prime. The beer was shipped to outside markets as well as the Grand Rapids market. The officers of the company were Phillip Kusterer, Adolph Leitelt and Charles F. Kusterer. The façade of the Kusterer Brewing Company took up 100 feet on Bridge Street and 140 feet on Ionia.

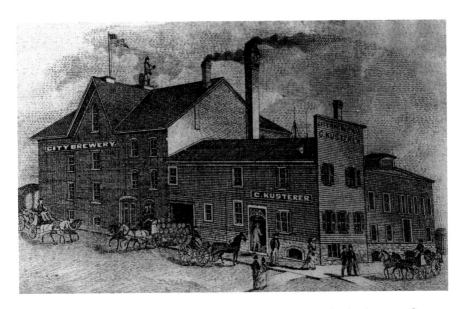

A drawing of Kusterer's City Brewery, Grand Rapids' first full-production brewery. *Courtesy Grand Rapids Public Library.*

The building had cellars claimed to be the largest in the city, capable of holding more than 3,500 barrels. The brewery had an annual capacity of 10,000 barrels. In 1881, a mash tun of 125 barrels, made by Chicago's Kattentidt, was installed.

Ads ran for the Kusterer Brewing Company in various publications, highlighting the Pilsener, Export and Stock beers the brewery produced, often above a picture of a cask. The brewery's phone number was 119, and orders for bottled beer were promised to be filled promptly.

Chapter 2
CHRIST BROTHERS

The three Christ brothers came to town in 1850 as part of a German immigration chain. Two of the brothers, Gustav and Christian, began work at Kusterer's operation.

Gottlieb Christ, the third brother, entered work at the Bridge Street House, a hotel at the time. The 1881 *History of Kent County* documented the building burning down in 1850, shortly after Christ took ownership with six other men. Christ ended up buying the property in 1856 when the hotel was rebuilt. Another record has Gottlieb Christ obtaining the first tavern keeper's license in the city, though some records have that coinciding with the opening of the Bridge Street House, while others leave no mention.

Gustav and Christian Christ's time with Kusterer was short. They found a parcel of land on Ottawa Avenue, between Bridge and Hastings Streets. They took their prior German beer knowledge and the practical experience earned in the local operation. On this piece of real estate they built an icehouse, malt house and brewhouse. Like other operations of the day, most everything took place on site, from malting of the grain to brewing and cellaring.

The Christ operation, known as G. and C. Christ, ran an advertisement in the June 1, 1859 issue of the *Grand Rapids Daily Enquirer and Herald*, firing some shots at other breweries in town at the time. The ad read: "Lager beer is played out, XXX Ale is nowhere when compared with the Bock Beer made by G&C Christ. The beer according to the analysis of Dr. DeCamp is a much purer article and considerably more healthy than any other beer."

A fire in Grand Rapids, often called the "Great Fire of July 13, 1873," took out the entire Christ brothers operation. The fire was described by

Baxter as "the most disastrous conflagration that ever visited the city—not perhaps in the amount of losses, but in the extent of territory burned over, and the number of families burned out." The fire burned along the north side of Bridge Street, up to Trowbridge and east to Ionia. Through the afternoon, when it started, the fire burned almost one hundred buildings and displaced more than 130 families. According to Baxter, "The day was very sultry, and the flames raged so fiercely that very little property from the houses was saved."

It didn't take long for the rebuild to come, as the community rallied around the brothers to raise the $50,000 needed to rebuild the brewing facilities.

The brothers' operation wasn't long for the city, however, as an apparent foreclosure took the business down. Two law journals, the *1892 Federal Reporter* and *1888 Federal Decisions*, both cited Gustav Christ as the defendant in a Michigan Circuit Court. The purchaser of the property wanted the brewing articles: two vats, a cask, a mash tub, a water tank, two fermenting tubs, a large pump, a copper cooler, a wooden cooler, a smaller pump and a bar counter out of the building. The articles were ruled too large to pass out of an existing opening and, therefore, a permanent part of the design of the building.

Baxter wrote that the fire and rebuild caused many complications for the brewery, but "theirs was a leader among the beer making houses while it stood."

A group of new investors had purchased the operation and helped grow it to include distribution in Petoskey, Traverse City, Charlevoix and other towns north on the Indiana Railroad and, to the east, as far as Pontiac.

BREWERS OF THE LATE 1800s

Increasingly Booming Industry

Baxter wrote that the industry grew to significant size fairly rapidly after 1850. By 1875, Grand Rapids had reached an annual production of sixteen thousand barrels of beer. Two years later, the industry was worth an estimated $600,000 annually, employing about 160 men.

In 1879, there were seven breweries in Grand Rapids, all owned by German Americans.

The *Grand Rapids Daily Leader* reported in January 1880 that the Grand Rapids breweries had produced 28,559 barrels in 1879. Kusterer produced 7,210 barrels; Frey Brothers, 6,803 barrels; Peter Weirich, 4,553 barrels; G. Brandt, 3,908 barrels; J. Veit & Co., 3,064 barrels; Tusch Bros., 2,624 barrels; Adrian Bros., 880 barrels; and Christ Brewing Co., 608 barrels.

Michigan Brewery

Bridge Street saw another brewery open in 1856, this time on the west side of the river, when Peter Weirich opened the Michigan Brewery on West Bridge and Indiana Streets. With the initial operation, Weirich had two buildings. In 1866, Weirich upgraded his facilities and tore down the originals.

Weirich, as did many of the other brewers, set up his establishment on the west side of Grand Rapids because of its proximity to the many furniture factories of the city, many of which were started by and employed many Germans with a thirst for lager.

Eight employees helped the Michigan Brewery push out thirty barrels of beer a day, according to the *Daily Eagle*. At this time, the three-story building was accompanied by an icehouse and included a significant bottling line. Weirich's industrial mindset didn't stay within the city limits, however. The entrepreneur owned and operated a farm in Walker that included two ponds from which Weirich harvested ice in the winter.

In 1870, more renovation and expansion took over Weirich's brewery, as a five-story building was constructed by Mr. H. Housery, complete with storage cellars arched with stone. The new additions made the facility the "largest and costliest building in the vicinity," according to the September 26, 1879 *Daily Eagle*. The new complex stood more than three stories tall and cost $25,000 to build.

The ground floor—or second, when factoring in the basement storage—was twelve feet high and used for brewing. The third was used for storage, including hops and malt. The fourth and fifth floors were used for malting. The brew system used steam brewing, utilizing a ten-horsepower engine powered by more than two hundred cords of wood per year. The building was high and gave rooftop views that were "very beautify [*sic*] overlooking nearly the entire city and several miles into the county in various directions."

Weirich's brewery was the site of a tragic accident in 1871. The *Daily Eagle* ran an article in February 1871 stating that a man named Anderson was "crushed by a piece of ice." The article said that Anderson "unfortunately met with a very painful and perhaps fatal accident Tuesday morning…a large cake of congealed water, weighing several hundred pounds."

In Robert H. Baker's 1889 Grand Rapids manufacturing history, he noted that Weirich's brewery had refrigerated cellars and water piped directly from his farm. At its peak operation, the Michigan brewery housed a seventy-barrel kettle and brewed approximately seven thousand barrels of beer annually.

Peter Weirich ran the Michigan Brewery until his death in 1886, when the brewery transitioned to the control of his estate, and the name was changed to honor him as the Peter Weirich Brewing Company.

Weirich's son-in-law, George C. Bratt, brought a former Stroh's Brewing Company employee to Grand Rapids to take control of the operation. Carl Kruschinski managed the operation and helped push its output. The Weirich operation would eventually turn into the Petersen Brewing Company in the early 1900s.

CIVIL WAR INFLUENCE

With a war ongoing in the South in 1863, George Brandt opened a brewery at 87 South Division. With the conflict in mind, Brandt named the operation Union Brewery in support of the Northern troops on the front line.

Brandt was the talent behind the brewery, as he had spent several years studying as a brewer under Christoph Kusterer at City Brewery, from 1856 to 1863, before splitting off with a desire to make a name for himself. He wasn't alone in the founding of the Union Brewery, however, as he was joined by his son George and Fred Mayer and Christopher Killinger. Brandt's wife, Elizabeth Fluher, also was a proprietor once they married in 1863. Their daughter, Caroline, ended up marrying into the Herpolsheimer

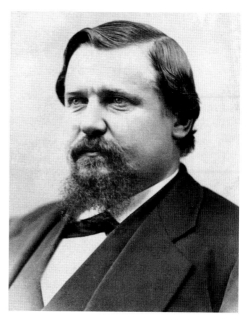

George Brandt opened Union Brewery in 1863 on South Division. He later joined forces with several other Grand Rapids brewers to create Grand Rapids Brewing Company. *Courtesy Grand Rapids Public Museum.*

family through Henry B. Herpolsheimer, the son of department store founder William G. Herpolsheimer.

The foursome put forward an initial investment of nearly $35,000, and shortly the brewery was churning at full speed, with the bottling operation bringing in more than $60,000 a year. Ice was a huge commodity, as with all the other breweries, and Union Brewery used more than eight hundred tons of ice every year.

The brewery was eighty-three feet by twenty-six feet and more than a story high. The facility also consisted of two ice cellars and two malt houses. The brewery used five horses and three wagons to distribute the beer.

A majority of the seven thousand annual barrels were lagers, but the brewery also produced a cream ale and a stock ale. All were shipped across Michigan. Some of Union Brewery's beer made its way into the office of the *Grand Rapids Daily Democrat* in April 1867, and the paper wrote, "While we are

31

of the opinion that the 'Good Templar' institute is all right on an average, and doing much good, still they have cut the acquaintance of 'lager,' and that's what ails them…and that's the rock on which we split; not that we love temperance less, but lager more."

The paper then went on to toast the Union Brewery in hopes it would continue to lager beer.

Brandt would eventually consolidate into the Grand Rapids Brewing Company in 1892, reuniting with the Kusterer family.

FREY BROTHERS

A trio of brothers was born in the middle of the 1800s in Württemberg, Germany. The eldest of the brothers, Adam, was born in 1839 and earned an adequate education, enough to be a practical businessman, and he took a variety of jobs in his early career. His specialty, though, was milling work until 1866, when he came to Grand Rapids. He stayed up to date on milling technology and methods and was a sought-after commodity in Grand Rapids. In 1874, he was offered a job by a brewery started by his brothers, Carl and Christian, who had recently come over to Grand Rapids from their homeland. The 1881 *History of Kent County* stated that Carl obtained a position in a Grand Rapids brewery for six years prior to the starting of the Frey family operation.

On the banks of the Coldbrook Stream, the two younger Frey brothers, Carl and Christian, established the Coldbrook Brewery in 1871. The building sat on Coldbrook Street, between Division and Monroe Avenue.

The first year, about five hundred barrels of an amber-colored beer was brewed. In an 1876 ad, the Frey brothers wrote that the bottled lager was intended for family use. The advertisement also said the beer could be delivered to any part of the city, free of charge.

Seven years after the first beer was brewed at Coldbrook, a three-story brewing building, a two-story bottling building and a 4,800-square-foot icehouse were constructed. At the new complex, more than ten thousand barrels of beer were produced and headed to Northern Michigan for sale.

The Frey brothers would consolidate with five other breweries in 1892 to form the Grand Rapids Brewing Company.

National Brewery

Growing up, Adolph Goetz spent time brewing in Germany and France, but his sense of adventure took him west. After crossing the ocean, Adolph Goetz spent 1870 in New York City before venturing to Cincinnati, then one of the biggest beer towns in America. In Cincinnati, Goetz likely spent a few years brewing at one of the city's many German breweries.

Goetz traveled north to Grand Rapids in 1874 and found work leading Christoph Kusterer's brewing operation. There he honed his brewing skills further before joining Kossuth Tusch in opening the Cincinnati Brewery at 208 Grandville Avenue. The Cincinnati name was meant to pay tribute to the high-quality beers that were made in the Ohio city where Goetz learned to brew. The brewery was near where Founders Brewing Co. stands today.

A few years later, Goetz sold his shares to Kossuth Tusch's brother, Frederick. The Cincinnati Brewery continued to thrive following the departure of Goetz, eventually pushing out more than ten thousand barrels annually.

Goetz's plan was to move to Colorado and strike it rich, but he came back to Michigan after being unsuccessful in the gold rush. He moved to Traverse City and brewed on contract before moving back to Grand Rapids and working again with Kusterer. Following Christoph Kusterer's ill-fated *Alpena* journey, Goetz started a saloon in the Pantlind Hotel. The saloon helped fund Goetz's new endeavor on the corner of Leonard and Broadway Streets, near where Engine House No. 9 and its Mitten Brewing

Adolph Goetz spent time brewing in France and Germany before heading to New York and then Cincinnati. He started two breweries in Grand Rapids: Cincinnati Brewery before heading to Colorado for gold and National Brewery upon return. He was the founding brewmaster of Grand Rapids Brewing Company. *Courtesy Grand Rapids Public Museum.*

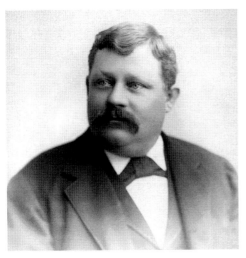 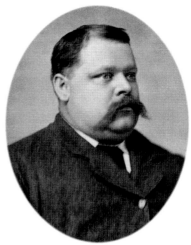

Left: Frederick Tusch bought Adolph Goetz's shares of Cincinnati Brewery to partner with his brother Kossuth. He was a founding member of Grand Rapids Brewing Company. *Courtesy Grand Rapids Public Museum.*

Right: Kossuth Tusch paired with Adolph Goetz to start the Cincinnati Brewery before consolidating into Grand Rapids Brewing Company in 1892. *Courtesy Grand Rapids Public Museum.*

Company now stand. The two-story building brewed more than 3,500 barrels of beer in 1886, its first year.

Goetz and the National Brewery would end up consolidating into the Grand Rapids Brewing Company in 1892.

EAGLE HAS LANDED

As an infant, Jacob Veit came to America and was raised on a farm. As a teenager, he secured work on a farm in Grand Rapids. During his time as a laborer, Veit elevated his social standing by accumulating friends through the west side social clubs, "no less for his sterling honesty than for his splendid business ability," according to Ernest B. Fisher in his 1918 history of Grand Rapids and Kent County. Eventually, he met Paul Rathman, a brewer from Breslen, Germany, who came to America in 1871. The pair joined forces in a brewery at 50 Stocking Street, near First Street, in 1876. As America celebrated its centennial, Veit and Rathman felt the proper name for the brewery would be one that

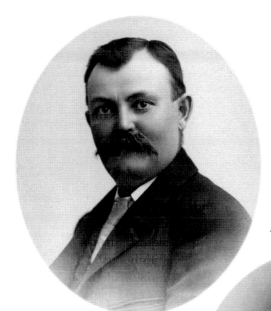

Left: Jacob Veit joined forces with Paul Rathman to start the Eagle Brewery in 1876. *Courtesy Grand Rapids Public Museum.*

Below: Paul Rathman teamed with Jacob Veit to start Eagle Brewery in 1876. *Courtesy Grand Rapids Public Museum.*

symbolized the nation, so the Eagle Brewery was born.

In the first year, Veit, Rathman and a brewer brewed nearly 2,500 barrels of lager. An advertisement for Eagle Brewery with a goat and an eagle in the corner suggests the brewing of a season bock beer.

In 1878, the original Eagle Brewery was torn down, and a saloon, two icehouses and two cellars were built to store beer through the winter. With the improvements, six men were now able to brew six thousand barrels annually, which were mostly sold within the Grand Rapids city limits. The brewery eventually employed more than a dozen workers.

In 1880, Jacob and his wife, Anna, had a son, Frank A. Veit. Once he was old enough, Frank A. Veit entered into an apprenticeship in his father's business, working his way from one position to another. He, like his father, was very active in the social community, including as a member of the Peninsular Club and the Elks.

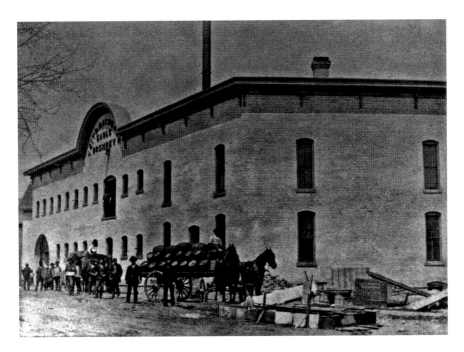

The Eagle Brewery location on Stocking Street. At its height, the brewery made more than six thousand barrels of beer annually. *Courtesy Grand Rapids Public Library.*

Veit and Rathman would join forces with five other breweries in 1892 to form Grand Rapids Brewing Company.

CHAPTER 4
MARKET INFILTRATED

In the late 1800s, breweries across the nation began to see Grand Rapids as a desirable market for their beer. With the increasing technology in transportation and refrigeration, it was easier than ever to transport beer. The first outside beer to penetrate the Grand Rapids market was from regional brewing power Toledo Brewing and Malting Co. By 1878, the beer was being imported to the city, including to a prominent Grand Rapids businessman, C.C. Comstock. According to a newspaper, a shipment of 250 kegs from St. Louis was addressed to Comstock, and once in town, the beer was stored in the cellars of Christ's Hall on Ottawa Street, between Bridge and Hastings Streets. The paper reported, "This is believed to be the opening of a new era in our trade with St. Louis, also the dawn of that happy period when beer will be furnished properly."

At the turn of the century, five outside breweries held Grand Rapids market shares, including Anheuser-Busch, Finlay Brewing Company of Toledo, Muskegon Brewing Company and Joseph Schlitz Brewing Company. Anheuser-Busch stated the first agency in Grand Rapids when the company was established in 1891. Muskegon felt its own pressure as Blatz Brewing Company set up an icehouse in the port city.

Toledo Brewing Company made its way into town when it set up a headquarters for a Grand Rapids operation on West Division Street. According to the October 13, 1886 *Grand Rapids Evening Leader*, a superintendent was placed in Grand Rapids, and he quickly acquired a

wagon and hired a crew. The operation was said to have cost the Toledo company $3,500.

While Germans dominated the brewing scene locally and across the nation, a few non-Germans tried their hands at the art in Grand Rapids in the mid-1870s. Aldrich J. Smith and William Draper started a brewery on Oak and South Division Streets. David L. Stiven made a go on Canal and Coldbrook, and the unnamed group about which Baxter wrote had made a go of it.

The *American Brewers Review* vol. 12 from 1899 announced that an Anheuser-Busch two-story warehouse was to be built in Grand Rapids. The building was set to cost $10,000. That same issue of the *Brewers Review* stated that someone wanted to introduce a celery beer to the Grand Rapids market to satisfy the preference of beer drinkers for putting celery into beer.

Despite the announcement in 1899, the warehouse wasn't finished until 1905. The building was part of a growing, nationwide network of rail-side icehouses, making wide distribution a much easier task. The beer was brewed and bottled in St. Louis and then shipped across the nation in train cars. Once the car reached a destination, some beer was unpacked and ice was replaced to keep the beer fresh until the next stop.

The building still stands near Van Andel Arena and can be spotted by its terra-cotta Anheuser-Busch "Eagle and A" insignias near the roof. The building now houses the Grand Rapids Community Foundation.

When the facility was in operation, the beer was delivered to Union Station, which sat where Van Andel Arena does today, and then was taken to the icehouse. From the icehouse, the beer was delivered in town by horse-drawn wagons and sleighs.

Many icehouses didn't make it long past Prohibition. "Prohibition hit brewers hard, which helps explain why only two Anheuser-Busch icehouses remain, ours and what's now a hobby shop in Van Buren, Arkansas," the Grand Rapids Community Foundation website reads. "Fortunately, local business owners had the foresight to preserve this building."

John E. Frey, a local Grand Rapidian, quickly ascended the ranks at the Grand Rapids Anheuser-Busch operation. He was a savvy businessman and realized finding a tenant for the icehouse during the "time of troubles" was a key move, so he sold it to Isaac Hecht Produce. The icehouse was eventually sold to Burge Chemical Products in 1966, which renovated the offices but left many of the historical elements intact. The business was dissolved in 2006, but Terry Wisner made sure to sell the building to a developer who cared about the icehouse's history.

A letter from Anheuser-Busch to Burge Chemical Products Company president Burgess L. Wisner in 1974 stated that the location was acquired for $15,000 in 1903 and the building had been constructed for $31,620.

These icehouses did not bottle or brew any beer, as Adolphus Busch held a tight hold on how Budweiser was brewed when he ran the company.

"Basically, our agencies served as direct contact between St. Louis, and in this instance, Grand Rapids. You might say they were the 'glorified' wholesalers of their day when compared to our modern-day distributors," the letter from Anheuser-Busch read.

During Prohibition, John E. Frey founded Union Bank & Trust. His son Edward J. Frey Sr. began Foremost Insurance and set up the Frey Foundation. The foundation is now chaired by Edward's son David G. Frey, who also serves as a community foundation trustee.

Part II

A New Age

CHAPTER 5
UNITED FRONT

Nearing 5:00 p.m. on August 7, 1895, a beer bottle was smashed and three cheers went up for Grand Rapids Brewing Company as a cornerstone was laid for a large, castle-like stone building.

The gigantic Bavarian-style building was designed by Chicago architect Lewis Lehle as the new brewing facility for the two-year-old brewing operation, a consolidated operation of six Grand Rapids breweries: Kusterer Brewing Company, Tusch Bros., George W. Brandt and Company, Veit and Rathman, Adolph Goetz and the Frey Brothers. Lehle was a nationally known brewery architect and had designed many during his career, including for Milwaukee's Blatz and Schlitz brewing companies. The walls of the building were four feet thick and reinforced by steel. The cement was brought in from Germany, specially designed for the gravity-fed brewing operations. The six breweries had a combined output of forty-five thousand barrels when they came together.

It also should be noted that around this time, two beer-related unions were started, the Brewers Workingmen's Union No. 10 and the Beer Bottlers and Bottle Wagon Drivers Local 254. The first year of operation as the Grand Rapids Brewing Company produced fifty thousand barrels while employing sixty of the unionized men.

A few years prior to the construction of the new Bavarian castle, the six companies were under pressure from the various outside breweries making their way into the city and providing stiff competition. In an effort to keep the local beer flowing, the brewers consolidated in December 1892 and opened

their doors at the Kusterer Brewing Company facilities at Bridge and Ionia Streets, as they were the largest and most advanced of the city's operations.

The consolidation was similar to what occurred in other cities. The breweries weren't large enough to capitalize on new, bigger and more advanced equipment to keep up with breweries like Anheuser-Busch, which had grown to a size that allowed it to invest in itself with massive amounts of capital to continue the rise to the top.

The path followed by Adolphus Busch might make one wonder what could have happened had Christoph Kusterer lived past 1880. Busch was an uncompromised businessman and earned community respect like Kusterer had in Grand Rapids. Busch invested heavily in the auxiliary infrastructure that supported the brewery, like railroads and cooperage companies, similar to what Kusterer did on a local level in Grand Rapids. Of course, Busch had the much-larger St. Louis market to work with, but in the early 1860s, the breweries were roughly the same size.

Following the consolidation, Grand Rapids Brewing Company purchased most of the facilities from the original breweries. The total capital of the consolidation was $500,000.

Many cities and regions saw breweries come together at this time to help combat the big beer coming into the cities, while larger regional breweries bought up smaller breweries to help ease growing demand instead of investing more capital. German consolidation was in contrast to another movement in the late 1800s by English brewers trying to consolidate operations and brew more ales.

The Grand Rapids Brewing Company's hierarchy looked like a who's who in Grand Rapids brewing history when the doors opened. Charles F. Kusterer took the reins as president, while Jacob Veit was vice-president. Frederick

C.E. Kusterer was a son of Christoph Kusterer, the city's original beer baron, and served as Grand Rapids Brewing Company's first treasurer. *Courtesy Grand Rapids Public Museum.*

A. Tusch served as secretary, and Christopher E. Kusterer filled the treasurer role. Adolph Goetz stayed in the brewhouse as the brewmaster of yet another brewing operation.

A report in the October 11, 1936 *Grand Rapids Herald* harked back on the 100th anniversary of beer in the city, noting that although the city was small compared to many others, breweries were a large industry. The six breweries coming together in 1892 was a huge mark in the city's history as "Grand Rapids began to take her place in the sun as a brewing center." In a way, it truly was the center, being in the middle of the German brewing triangle of Cincinnati, Milwaukee and St. Louis.

By 1899, Christopher E. Kusterer had become crippled by stress. The twelfth volume of *American Brewers Review* noted he "broke down with overwork last summer and still continues in a condition incapacitating him from resuming his duties." That year, Grand Rapids Brewing Company also invested $52,000 into a new bottling plant.

Once Frank Veit took over as president, Grand Rapids Brewing Company saw rapid growth. There aren't historical records that prove it was Veit's doing, but it was noted in the 1912 *American Brewers Review* that the brewery "developed under his management into one of the largest concerns of its kind in the country."

In 1900, company officials said, "Fame of their Silver Foam brand has spread from state to state until it is demanded in all parts of the country." Many publications were quick to give credit to the hillside spring Christoph Kusterer so wisely built on nearly fifty years before. This fame of the Silver Foam brand necessitated the building of a new bottling department, as the brand needed to be transported to all parts of the country.

Kusterer's spring was now enclosed by a cooler room, which filtered air and light before it could touch the water so precious to the brewing process.

Grand Rapids Brewing Company was one of seventy-five breweries in Michigan in 1904, according to a Michigan Department of Labor report. "It cannot be successfully controverted that this is a most important industry," the report read. Sixty-nine of those breweries were located in forty-two cities in twenty-nine counties, with more than $5.5 million in capital invested. Those breweries brewed 919,139 barrels of beer per year while running at full capacity with 1,088 employees. Roughly 90 percent of the beer was sold in Michigan, with the excess heading to West Virginia, Maryland, New Jersey, Ohio, Pennsylvania, Indiana and Wisconsin.

As part of the massive complex, the Grand Rapids Brewing Company had a horse stable for the company's delivery horses. Above the entrance to

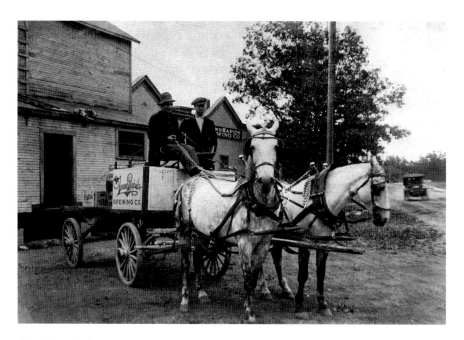

Grand Rapids Brewing Company delivery wagon being pulled by the company's famous horses. The logo still used by the modern incarnation can be seen on the side. *Courtesy Grand Rapids Public Library.*

the stable were beautiful horse heads, which signified the type of building it was. These horses were famous in their own right, much like the Budweiser Clydesdales that have come to fame in the late twentieth and early twenty-first centuries. The *Grand Rapids Herald* wrote in the early 1950s that the horses of Grand Rapids Brewing Company did much on their own outside of delivering beer, including winning ribbons of excellence at county fairs.

Grand Rapids Brewing Company installed twenty-two glass-enameled stock tubs, provided by the Detroit Steel Cooperage Company, in 1905. That same year, a building was constructed that included apartments, an auditorium and a storage area, designed by local architect Christian G. Vierheilig. The expansion cost $50,000.

It took two more years, including a full year of construction, but on August 17, 1907, Grand Rapids Brewing Company had a new, separate bottling plant. The day's *Grand Rapids Evening Press* ran an advertisement stating, "After a Year's Work at a Cost of $100,000 the New Bottling Plant of the Grand Rapids Brewing Company Is Completed. Visitors Are Invited." The advertisement also said that, at the time, no other plant had the same combination of bottling features and detailed the company's sanitation efforts.

Silver Foam, the brewery's staple lager, was increasing in popularity by 1900. Advertised in the *Grand Rapids Medical Monthly*, Silver Foam was sold as a health drink, "brewed with the best Bohemian hops, choicest malts and purest spring water, therefore a most healthful stimulant." White bottles held the liquid, further described in the ad as "Our Great Health Restorer, Malt and Hop Tonic."

By 1905, the brewery had increased its annual capacity to more than 130,000 barrels. The need for more space for this increased production led to the brewery purchasing a school building across the street from the complex in 1908. *Grand Rapids Herald* writers reminded readers the same year: "[The school's] location has also been the source of a long standing pun. On one corner was the school, on another was a church, while on the third was a saloon. In consequence of this combination, the saying has grown that on three corners were located education, salvation and damnation."

In 1909, the *Grand Rapids Herald* celebrated April 25 as Bock Beer Day, writing, "Gurgle, gurgle, giggle, guzzle, smack—yumyum."

Three of Grand Rapids Brewing Company's original officers died in 1911, capped by Jacob Veit's death in December. The company wasn't surprised, as Veit had been sick since October. F.A. Tusch died in October of that year. Brewmaster Adolph Goetz had stomach problems and had undergone a surgery at Chicago's St. Augustine's Hospital. The operation unsuccessful, Goetz came back to Grand Rapids and withered at his 175 Michigan Avenue home until March 10, 1911.

A new $100,000 portion of the property was opened in early April 1912, said to be the finest in the area.

In 1913, the *Grand Rapids Herald* recognized the company as one of the leading breweries in the Midwest and featured a large article on it, highlighting the production process of the brewery. The *Herald* takes the readers through the entire brewing process from milling grain to fermentation. The *Herald*'s description of the brewing process was rather elementary, talking in basic brewing terms and sparing readers an in-depth lesson. Grand Rapids Brewing Company had thirty-two 150-barrel open fermenters, made from California redwood.

The article explains that Grand Rapids Brewing Company used an elevator to move malt to upper-level storage bins and used gravity to lower it to brewing systems. Oddly enough, in contrast to modern times, the author of the article said Grand Rapids Brewing Company used corn and rice in production, like many other American breweries of the time, explaining that adjuncts are not used in Germany, "not for the reason of securing a fine

quality of beer, but because corn and rice are not produced in Germany. Indeed, the best authorities today favor the use of corn or rice with the malt."

The article went on to say, "A very important part of the brewing process as seen at the Grand Rapids plant is called mashing. This takes place in the mash tank. In the cooler the ground grain raw materials have been cooked and now they come to this tank where they are mixed with boiling water. The tank has a perforated broom and through this comes what is known as the clear 'wort.' From the mash tank the wort goes to the kettle, where it is boiled and hops are added. After the hops are added the liquid goes to the hop jack and then it is pumped to the cooler up stairs [*sic*]. The next step is a descent to the settling cellar. Here yeast is added and fermentation begins."

Grand Rapids Brewing Company stuck to purist routes when it came to hops, however. The company was said to never use chemical hop substitutes, purchasing hops once a year from Washington, Oregon and Germany, the same places from which many of today's hops are sourced. Hops were stored at low temperature, "so as not to become rancid." Grand Rapids Brewing Company brought in large quantities of supplies once a year to ensure constant quality with little variations in the beer.

Grand Rapids Brewing Company also made its own yeast from original strains from Munich and Vienna and often went under the microscope to ensure the quality. The quality control laboratory could rival those of the modern breweries, according to the histories. Brewers would extract one cell from a previous batch and grow it to more than four hundred pounds of yeast within five weeks. A trained chemist would extract a healthy cell so as not to propagate bad cells.

Fermentation at the brewery was open and "presents to the observer a most beautiful appearance. A white foam would cover the beer within the first few hours, morphing in and out of shapes. Eventually, a cover of jagged white snow-like foam would take the scene. With these phenomena the artistic beauties of fermentation disappear although the fine thick head of yeast whig follow delights the eye of the practiced brewer for it tells him that the fermentation is drawing to a successful end."

Initial fermentation took twelve to fourteen days. Following fermentation, the beers were transferred into another set of wooden tanks in the cellar, where the beer lagered for six months, "during which time it ripened and matured." Records show the light beers were aged for one hundred days.

The finished product came out nearly seven months from the original brew date and was put into wooden kegs or sent to the bottling line, which

was capable of packaging four hundred barrels of beer in ten hours. At the time, the brewery distributed four beers to the masses: the famous Silver Foam lager, Export Lager, Pilsner and an Alt Nuernberger.

Kegs were returned to the brewery and would run through a machine for a complete washing and sterilization. The machine was said to have cost a great amount and came from Germany. The kegs would be inspected and, if necessary, run through the machine again. Bottling was more sanitary. New and recycled bottles would run through a rinser before being filled and capped automatically. The full bottles then ran through a pasteurizing process, ensuring the death of any yeast and bacteria in the bottle and allowing bottled beer to last longer than that in kegs.

Following the description of the process, the author of the article wrote, "No one can go through the plant of the Grand Rapids Brewing Company and not feel very deeply that the modern brewer is not like his ancestor, a bungling workman and empiricist. Rather he is an educated observer of scientific laws who has an adequate knowledge of chemistry and biology and who follows out well established rules in his everyday work in order to conform to modern tastes and modern economy."

It seems as though this article was partly an advertisement, as another reader had summarized it as a statement to distance the brewery from the anti-German sentiment sweeping the area at the time. This sentiment was linked to the temperance movement because of the connection German immigrants had to the beer industry and the growing tension in Europe.

Still, truth rang through the article, and it still resonates today. Brewing is a clean industry, and much of the workday of brewers is spent on sanitation. The article detailed a boy's reaction following a tour of the brewery.

"I wish my mother could see this," he blurted out. "She has always told me that there is nothing so dirty as beer. I don't believe there's anything so clean. Why, our kitchen at home isn't half so clean as this plant is kept."

Another feature was run that year in the *Herald* that stated, "The company's establishment is stupendously large and it takes no little time to go through it. But it is time well spent for one can follow the various manufacturing operations from the time the malt is hoisted to the very top floor until the bottles and kegs are ready for distribution."

The *Herald* later said that the brewery's beers were made only of water, yeast, corn, rice, sugar and barley, but "the man that mixes these cereals must be a highly trained chemist and bacteriologist, and he can never make mistakes, for a very slight error would mean great loss to a brewing company."

Brewing capacity was nearing its height, but the Grand Rapids Brewing Company had nearly twenty saloons in its ownership and began selling them off, including six of them in August 1913.

The following year, George Brandt saw an untimely death when he was involved in a car accident in East Grand Rapids. At the time, Brandt was the president of Grand Rapids Brewing Company and had then vice-president Gustav Kusterer in the car as well. Also killed in the crash was William N. Viet, the brother of Frank Viet, then the superintendent and brewmaster of the brewery.

Grand Rapids Brewing Company had a capacity of 610,000 barrels in 1916, far more than any other brewery in the West Michigan area from that point until the present day. No records reported an actual output, and 250,000 annual barrels is the largest recorded (Founders Brewing Co. should pass that capacity in 2015). It was noted by *Michigan Tradesman* that exceptional management and the central location in West Michigan allowed the brewing company to grow to its impressive size, equaled by only two or three breweries in the Midwest. Like other major breweries, Grand Rapids Brewing Company had opened icehouses in various cities, including Hillsdale, Muskegon and Cadillac.

The January 1917 issue of the *American Brewers Review* ran a brief that said, "Grand Rapids Brewing Company intend establishing a chain of grocery stores should the Michigan Legislature's stupid Prohibition law become operative."

In 1918, shortly after the Prohibition news hit the streets, Grand Rapids Brewing Company announced dividends of 15 percent, which would continue until the beginning of Prohibition. The company's stockholders voted to organize the Grand Rapids Product Company for $400,000. The trustees were G.A. Kusterer, Frank A. Veit, John Knell, A.E. Kusterer and David Uhl. Grand Rapids Brewing Company ceased to be an operating company but maintained ownership of the property, machinery and other facilities for manufacturing. The company would make an ethyl alcohol and a byproduct Silver Foam.

"In other words, Grand Rapids Brewing Company put the kick in Silver Foam and Grand Rapids Product Company will take it out."

On the last day of sales on April 27, 1918, Grand Rapids Brewing Company sold beer out of the factory. More than twelve thousand orders were reportedly refused, as Adolph Kusterer, the company's president at the time, said, "Our stock is all gone, and we're through for good."

CHAPTER 6
EARLY TWENTIETH CENTURY

Although the Grand Rapids Brewing Company was the dominant force in the region for brewing, several other breweries made their home in the city.

The first of the "other" breweries was Petersen Brewing Company, which was founded by Julius R., Henry C. and Philip Petersen. The brewery, located at 296 Bridge Street, employed four people and brewed about five thousand barrels of beer. The brewery was located in the old Weirich brewing building.

The Petersen, Wippfler Co. had purchased the company from Weirich's estate for $17,000 in 1894, but the full reorganization into the Petersen Brewing Company didn't happen until 1901.

Valley City Brewery filed articles of incorporation in 1903, according the *Michigan Investor*. The capitalization of the brewery was worth $350,000, with $126,000 paid at the time of the article's publishing. The purpose of the company was to sell malt and fermented liquors, as well as "aerated and charked waters."

Elias Aberle, a promoter from Detroit, saw an opportunity to capitalize on the city's furniture notoriety and came in to start Furniture City Brewing Company. Aberle had helped start breweries in Detroit, Port Huron, Lansing and Battle Creek, Michigan; Toledo, Youngstown and Columbus, Ohio; and Atlanta. Many of the investors were owners of Grand Rapids saloons who would help sell the beer.

A local businessman was elected president of the Furniture City Brewing Company when C.F. Youngs resigned before the operation was even

running. John H. Bonnell of Hackley-Phelps-Bonnell Company was named to the position from the board of directors shortly before Detroit contractor A.F. Cramer came to the city to oversee the construction of the brewery. A brewmaster from Detroit, William Wecker, also arrived to take charge of the cooperage construction. The construction was done by Detroit's Huetterman & Cramer Company, with no limit on the price, just the instructions to build the best possible building.

Furniture City Brewing Company began in March 1905, as the brewery and large bottling department was started on the corner of Ionia and Wealthy Streets. Oddly enough, a bottle of wine was broken atop the cornerstone by the brewery's vice-president, W.C. Chinnick. Other officers of the company "gleefully drank champagne while standing in the mud about the cornerstone. Branet cigars in plenty will be distributed. Those who prefer to drink beer rather than champagne will be served with Grand Rapids brewery beer," the *Grand Rapids Herald* reported. The first beer wouldn't come out of Furniture City Brewing Company until the middle of May 1906, but expansion quickly came to

Furniture City Brewing Company opened in 1905 by out-of-town investors and was located on the corner of Ionia and Wealthy. *Courtesy Grand Rapids Public Library.*

Furniture City Brewing Company, and the capacity of the company was upped to forty thousand barrels annually.

A collection of breweries from across the state came together to become a cooperative of sorts, according to a 1905 issue of *Michigan Investor*. Twenty-eight breweries came together to form a $6 million 500,000-barrel collective. The organization's president, F.A. Hect, was from Chicago, although there was no mention of Chicago being in the organization. He said the purpose of the collective "is in no sense a combine or trust. It is more in the nature of an association for the purpose of putting the sale of beer on a commercial basis and eliminating the illegitimate and sand-bagging [*sic*] saloon element. The association is designed not only for the benefit of the brewer, but also for that of the consumer."

In 1907, the Grand Valley Brewing Company opened operations in Ionia through capital invested from several Ohio investors. The brewery was led by Ionia's John Koerber, but the major investors came from Cleveland and Akron, including C.A. Case, George Lomnitz, J.P. Loomis and F.R. Skunk.

CHAPTER 7
PROHIBITION HITS

G rand Rapids had seen a battle for temperance for most of its existence. The temperance movement came early, when Reverend James Pallard preached for total abstinence from intoxicating beverages in 1838. Founding Grand Rapidan Lucius Lyon was the president of the first temperance society, called the Washingtonians, in 1812. By 1843, the local chapter of Sons of Temperance had more than one hundred members.

The Maine Law was submitted to popular vote in June 1853 and passed, with 337 of 608 of the county's residents voting yes. Manufacturing and selling alcohol was forbidden under this law. At the time of that vote, barrels of whiskey were cracked open and dumped down Monroe Avenue. Despite the local ban, the relatively wild men of the local lumber industry led to a general disobedience among the population before the law was repealed. The January 3, 1858 edition of the *Daily Enquirer and Herald* ran a correspondence from the *Livingston Republican* calling the rum shops of Grand Rapids "breathing holes of hell."

According to some histories, there were some laws on the books, but residents blatantly ignored the laws. In 1874, the Ladies of the Christian Temperance Association would visit saloons and pray to the owners to quit the business. Eventually, the city's druggists pledged not to sell liquor except for medicinal purposes, which, of course, was a common purchase.

Liquor taxes went through the roof in the summer of 1875. If prohibition didn't help the temperance movement in preventing the general population from drinking alcohol, the thought was that increased taxes would. A $40

annual tax was imposed on beer sellers and $50 to $300 on breweries, based on production levels.

"Through all the mutations of efforts for its restraint, the liquor traffic of the city appears to have thrived and much of the time as profitable to the deals as other trades and occupations," according to a summation of the temperance movement by Albert Baxter in 1891.

Drunkeness was a point of humor in the 1800s, as noted by an article in the September 26, 1879 issue of the *Grand Rapids Daily Eagle*. It told the story of a drunken man found on the sidewalk outside of "one of the great furniture factories." The employees "took care of him" by placing him in a box and nailing boards over him so he couldn't get out. They then labeled the box "dead." According to the article, hundreds of spectators gathered. When the man sobered up and came to, the article said, "his feelings and actions may be more easily imagined than described. He learned a lesson."

Holland was strongly in favor of a constitutional prohibition as early as 1887, according to the March 14 issue of the *Muskegon Daily Chronicle* of that year. The article stated that Hollanders from across West Michigan were in attendance at a temperance meeting at the First Reformed Church, and the proceedings were all in "the Holland language."

In 1909, Mayor George Ellis invited brewers to join him in limiting the saloon. The three breweries joined the movement to eliminate some of the city's saloons. The Cramton Bill would limit Grand Rapids to 120 saloons, or one saloon per one thousand people.

In a 1910 *Grand Rapids Herald*, an advertisement was run suggesting that prohibition would not save homes, as some temperance advocates would suggest. In the advertisement, it was said that dry Kansas saw one in fifty people divorce, while Michigan, still a wet state, saw one in fifty-six citizens divorce.

Another advertisement appeared in the September 27, 1914 *Sunday Morning Herald*. It stated that beer satisfies a demand while not creating a habit. In 1913, sixty-eight million barrels of beer were produced in America, 80 percent of which was manufactured and consumed between June and September. Seventy-five percent of the beer was consumed at homes or in hotels, the ad read. It went on to say, "Beer supplied a natural demand. It's [*sic*] consumption falls with the thermometer. We drink it in the summer months as a refreshing tonic. Cool, sparkling, and invigorating, to rejuvenate jaded spirits and appetites. The bare facts verify the claim that beer is a temperance beverage and that temperature is the rule of 'not too much,' that beer is not drank as an intoxicant, but rather as a beverage."

Anti-German sentiments after the outbreak of World War I were strong and often tied to beer because of its strong German heritage. The nearby town of Marne was once called Berlin before its name was changed in 1919 to honor the soldiers lost in the Second Battle of Marne.

Grand Valley State University professor William Seeger said the sentiments were far worse in the First World War than the Second, as the large ethnic populations hadn't fully united as distinct communities. Still, Seeger equated the sentiments toward Germans in the First World War to those the Japanese saw in the Second. By the Second World War, those of German heritage had learned how to ignore the discrimination and embrace the war movement, including helping to manufacture war materials.

But as the Great War heated up in 1916, there was a huge push to stop the drinking of German beer. "There were movements to 'drink real American beer,'" Seeger said. "People were beating the drums against Germans and saying no to the 'evil Kaiser brew.'"

Michigan voted to go dry on May 1, 1918, more than six months before the Eighteenth Amendment was ratified on January 29, 1919.

Sensing national prohibition was near, the three Grand Rapids brewing companies strove to find a way to battle the financial stress of not being able to make beer. The owners had no way of knowing if and when the ban on alcohol would end. Holland Brewing Company turned into a cheese factory following more than fifty years of brewing history.

The *Grand Rapids Press* wrote on July 12, 1917, "With state Prohibition coming in May 1918, the city's three breweries are exploring other ways to make money. Petersen Brewing on Bridge St. is already making 'Vita,' a soft drink that tastes like beer. GRBC, which owns or leases a chain of saloons, and Furniture City Brewing Company both are considering getting into the grocery and dry goods business."

Petersen Beverage Company's Vita was a soft drink that tasted like beer, with little alcohol, though it still contained some. Furniture City ended up making a drink called Nu-Bru, another version of nonalcoholic beer, and also sold ice out of the company's ice warehouse.

Michigan's manufacturers were forbidden from producing alcoholic products in 1918, but the state was "moist." During the year, Michigan allowed other states' alcohol producers to ship into the state.

Michigan became the sixteenth state to ratify the Eighteenth Amendment, and two weeks later, Nebraska gave the nation the three-fourths vote needed to exile alcohol from the nation.

When Michigan's Prohibition began, a South Division Avenue bistro posted a streamer that read "Gone, but not forgotten." More than 3,200

bars closed in Michigan, and 8,400 workers who made and served beer were out of jobs.

Fresh off a trip to the Upper Peninsula investigating a rum rebellion in Iron County, George Cummerow returned to a room in the Pantlind Hotel on March 3, 1919. The special agent in charge of Grand Rapids for the Department of Justice was arrested after serving whiskey in his room. The same night, Charles Gillette, the "King of Grand Rapids Bootleggers," was arrested and hurled booze bottles as he was taken into custody.

In 1922, Grand Rapids saw several raids. In a February 4, 1922 issue of a local newspaper, warrants were issued for Peter Campione, Mrs. Constantin Rucinski and Bert Geski. The three were arrested. At the Campione home, officers found a still set up for operation, including 9 gallons of moonshine and 115 gallons of mash. Mrs. Rucinski was deprived of 50 gallons of mash and 2 gallons of moonshine. Warrants were also issued for Mrs. Etta Van Harn and Mr. and Mrs. John Dornbbs. At the Van Harn house, a 10-gallon still was found, along with 120 gallons of mash and 1.5 gallons of moonshine.

The same issue stated that Peter Van Setters was "too persistent in telephoning activities of bootleggers to police headquarters. Because he called the station eight times, the answering clerk told him to wait at Ottawa Avenue and Coldbrook Street, while Special Officer Barney Parkhill dispatched and escorted Van Setters to the station. He was drunk."

Prohibition might have forbidden the sale of alcohol, but the American population grew desperate in its need for a relief in life. During the 1920s, Americans would drink anything they could get their hands on, from bootleg liquor to bay rum to tonics and imported bitters. According to Dr. W.L. Linder, an Internal Revenue Service chemist, "The medicine must be tasty or it would nauseate the really sick people who need it. Taken in large quantities, sufficient to produce intoxication, these medicated preparations are very harmful, however, because the drugs they contain have a greater effect than the alcohol on the drinker." During Prohibition, drinkers would pay between $8 and $10 for a quart of whiskey, more than $100 in 2014 currency.

A graph in a publication supporting Prohibition showed that from 1917 to 1922, arrests in Grand Rapids were cut in half, thanks in part to a drop in intoxication cases, which dropped from two thousand in 1917 to five hundred in 1922.

The Grand Rapids Association of Commerce published the *Grand Rapids Progress*, which reported in 1922:

> *Home brew became the vogue, a couple of mashes was 'bout the limit, or messes, the stuff was poor, not even palatable and there was no health in it.*

Then came the bootlegger with his moonshine and faked imported good. The prohibitive price charged for the vile decoctions made thousands of converts to prohibition. Of course, there is still much drinking and bootlegging, but I believe the signs of the times are toward effective enforcement of the law and eventual total abstinence. All history shows that any new law which interferes with so-called personal liberty of the community must pass through the stages of open violation, secret violation, passive enforcement, and then universal observance. I look upon this gentleman bootlegging, this society of bedroom and bath nipping as just a passing fad and will wane and eventually pass altogether. It simply isn't worth the trouble or the cost, for strong drink never increased any man's efficiency. It may however rob him of his friends, his money, his manhood and cause his children to remember him with loathing. That price is too big to pay for a shot of poison.

Thanks to Michigan governor Fred W. Green, the state had the harshest penalties for bootlegging, homebrewing and other manufacturing of illegal beverages. Any offenders could spend up to four years in prison or owe $2,000 for a first offense.

Local breweries were suffering just as much as individuals. In 1923, all of the Schlitz Brewing Company property in Grand Rapids, worth more than $325,000, had been sold off.

A month after Elvin Swarthout took the mayor's office in Grand Rapids in 1924, there was a raid on Petersen Beverage Company on Bridge Street. In the raid, police officers found moonshine, grain alcohol, wine and hundreds of gallons of beer.

On April 13, 1926, Earl W. Munshaw opened the "Rum Row" war in East Grand Rapids. He worked undercover and surveyed a spot near Reeds Lake that had freely run with beer for more than a year. After a short time of surveillance, Munshaw arrested Mr. Olive St. Clair and Mrs. Anna Hite, charging both with selling beer.

Prohibition couldn't make it, as Michigan was the first state to ratify the Twenty-first Amendment, signifying the desire to quickly consume booze legally again. The position was supported by Governor William Comstock, who said, "Prohibition didn't prohibit." The mayor went on to describe the vote as "good common sense and judgment…We have decided to try personal liberty once more, the personal liberty we had before Prohibition."

In 1934, as beer was back in vogue following Prohibition, beer sellers were trying to outdo one another, some selling twenty-four-ounce glasses for a dime and others selling two bottles for a nickel and dime.

Part III

POST PROHIBITION

Chapter 8
First Sips

The nation's breweries faced a trifecta of circumstances that led to many going out of business before, during and following Prohibition. The first was World War I, which was a partial influence for Prohibition because of the growing animosity toward the large German contingent of brewers.

Prohibition, of course, was the biggest factor. Most breweries had their plans of how to turn a profit during the nation's abstinence from alcohol. Unfortunately for many of the brewers, there was no sign to tell them the Eighteenth Amendment would last little more than a decade. With so many companies producing nonalcoholic "near-beer" products, there wasn't much market room. Many companies in the nation—including Grand Rapids Brewing Company, Petersen Brewing Company and Furniture City Brewing Company—ceased operation of the products that had replaced beer. Grand Rapids Brewing Company had relinquished its control of its massive building. Furniture City Brewing Company's building was foreclosed on in 1929 by George C. Ellis's company.

Meanwhile, some breweries were able to survive by conducting other business during Prohibition. Breweries such as Stroh's and Yuengling started extremely successful ice cream companies. Anheuser-Busch made ice cream, truck bodies and a variety of other products that were able to get it through the tough times. Coors sold malt extracts that were turned into a variety of products by other companies, including candy from Mars.

The tough sales during Prohibition were made worse by the Great Depression and likely contributed to the rapid demise of small regional

breweries nationwide. Larger national and regional breweries were able to utilize their previous markets to rebuild their operations. Although Anheuser-Busch built new breweries in cities on the East and West Coasts to satisfy growing demand, others, like Schlitz, Pabst and Miller, grew by purchasing existing breweries so as to not spend extra money on equipment.

Grand Rapids Brewing Company reincorporated as an operational company in November 1933, with the intention to make "legal beer."

In January 1934, Grand Rapids Brewing Company merged into a $750,000 corporation with Furniture City Brewing Company. The company didn't resume production until prominent local businessman Frank D. McKay, of McKay Tower fame, bought the Muskegon Brewing Company and helped Grand Rapids Brewing Company resume production at that factory, as he was acting secretary-treasurer. The offices were still in Grand Rapids, and the beer was shipped down to Grand Rapids. Unfortunately for the company, the beer, including Silver Foam, never returned to its pre-Prohibition heights. The brewing continued in Muskegon until it was eventually dissolved when Detroit's Goebel Brewing Company purchased the property.

Imperial Brewing Company was formed in 1933, turning into Old Kent Products Company Brewery a year later and finally becoming the Valley City Brewing Company. The company produced Valley City Beer and Lohman's Ace High Beer until 1940.

Long before Cleveland's Great Lakes Brewing Company opened and produced craft beer, the Great Lakes Brewing Company was formed in Grand Rapids, occupying the Petersen Brewery site on Indiana and Bridge Streets. Although licensed, the brewery never produced a pint of beer.

An article in the March 25, 1936 issue of the *Michigan Tradesman* made sure to note that the climatic conditions in northern states were ideal for brewing beer. The article stated that America had the ideal grains, water and technology to make lagers of superior quality, and the use of filters helped expedite the beer and get the liquid on the market quicker.

The same article noted that 80 percent of the nation's breweries were in the Northeast section of the United States, including forty-three in Michigan, with the state's beer headed as far south as Texas, as well as to states coast to coast.

For eight months, Walter J. Conlon and his company prepared to open the Michigan Brewing Company, which had purchased the old Grand Rapids Brewing Company building in early 1936. When the brewery was ready to open, the *Grand Rapids Press* and *Grand Rapids Herald* both ran large features

on the history of beer in Grand Rapids. It appears as though the Michigan Brewing Company opening was one of much fanfare.

Since 1918, the giant Bavarian-style building had mostly sat vacant, used as a warehouse. Prior to the newest brewery operation, a lab analysis of the spring water was sent to Wahl-Heniuss Institute of Chicago, and results for the water came back as "exceptionally satisfactory for brewing purposes."

Michigan Brewing Company had taken over the largest brewery in Michigan outside of Detroit with the intention of brewing roughly 300,000 barrels of Old Michigan beer for the Grand Rapids and West Michigan market. For the building, the new company spent approximately $1 million, all told. Old Michigan beer was, according to Conlon, "a true Pilsener-type lager, made from the finest malted grain available, together with other selected grain products. The flavor arises from a careful blending of domestic and registered imported hops of the Saazer strain. No glucoses, sugars, sirups [sic] or coloring matter is added at any stage of the process, and the character of the beer is derived entirely from the natural brewing of the ingredients."

The eight-month span from purchase to operation was for good reason. Conlon wanted to ensure a top-tier operation, and all the equipment when the brewery opened was built to order. Large cellar space was often the point of conversation, as large refrigerated cypress tanks offered an ideal centerpiece. The tanks were twelve feet in diameter and forty-two feet long and were said to be the largest in the world, according to makers. Lined with glass, the tanks were easy to clean and kept the beer pure.

An article in the October 10, 1936 *Grand Rapids Press* said the brewhouse was the only Munich-style structure in Michigan, and many sightseers were interested in the 350-barrel copper brew kettle, filtered air cooling room and riveted-steel malt hoppers, each five stories tall.

The article also detailed the brewer who would lead the Michigan Brewing Company operation. His name was Frank E. Weber, and he possessed all the necessary skills a modern brewer could want. The article said, "No famous cook serves a more rigorous apprenticeship than the man whose destiny it is to supervise the operations of brewing. For the master brewer is not only a meter of flavors, he must be a scientist, a biologist, a chemist, a laboratory technician and last of all, a production executive."

The article noted that master brewers had to be born, as well as trained. Old Country breweries were restricted to family members of brewers, and Weber's family had seen his father and grandfather at the helm of breweries as well. Weber earned his master brewer wings at twenty-two years old. He ventured to Chicago and worked at one of the largest Windy City operations,

Citizens Brewing Company, and at twenty-six, he made his way to Muskegon Brewing and Bottling Company, working on the lakeshore for twelve years.

"I had to sprout a handlebar mustache to look old enough to land that job," Weber told the *Press*.

During Prohibition, Weber made near beer in St. Joseph, Missouri, before heading to Carling's Brewery in London, Ontario.

A breakdown of the Michigan Brewing Company's market was from Sault Ste. Marie down through Indiana, an area with approximately 1.6 million people, roughly the same as Detroit. It was then noted that the eastern half of Michigan consumed 1.7 million barrels of beer per year and Western Michigan only consumed about 900,000. This market analysis hinted that Michigan Brewing Company had plenty of room to grow but that Detroit's concentrated home market also was much more suited to house a brewery of that size.

Old Michigan beer was to be delivered on draught and was done so in metal kegs, a technology to which Michigan Brewing Company had exclusive rights in the West Michigan territory.

"The metal barrel is here to stay," comptroller Will A. Voss told the press. "While the old-time coopers developed a wooden barrel of fine quality, it was never possible to guard against serious damage and loss of beer in transit." The company also distributed small, twelve-ounce bottles.

By the end of 1940, though, the company's assets were sold to Chicago's Peter Fox Brewing Company. When it changed hands, Michigan Brewing Company was brewing with a capacity between 400,000 and 500,000 barrels of beer a year, good for second in the state, behind Detroit's Stroh's Brewing Company. Still, the brewery seemed to stall at about 250,000 barrels of beer per year.

Peter Fox Brewing, or Fox Deluxe, was formed in 1933 when the nine Fox brothers purchased Hoffman Brothers Brewing, reportedly from the famous Al Capone, for $500,000 in common stocks. Expanding in cities across the Midwest, including breweries in Oklahoma and Indiana, Fox Deluxe took control of the Michigan Brewing Company and the old Grand Rapids Brewing Company building in 1941. At its height, Fox Deluxe brewed more than 1 million barrels of beer a year, ranking as the thirteenth-largest brewery in the nation, higher than Miller Brewing Company at the time. Of those 1 million barrels, 250,000 were brewed in Grand Rapids, according to city directories at the time.

The final brew at the Grand Rapids Brewing Company building by Fox Deluxe was in November 1951, when the company shifted all of its production to Chicago. Final shipments of beer left the building on December 13, 1951, before it was shuttered and left vacant.

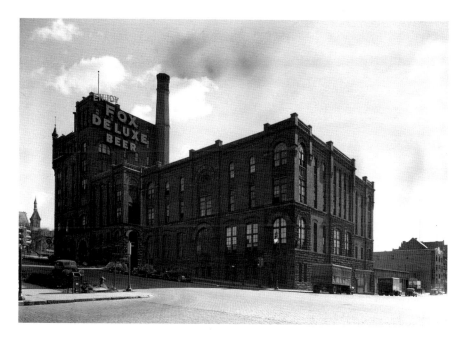

Fox Deluxe Brewing Company took over the Grand Rapids Brewing Company building in 1940 and operated until 1951. The building was torn down in the 1960s. *Courtesy Grand Rapids Public Library.*

December 14, 1951, saw the *Grand Rapids Herald* run a brief detailing the history of the historic German-inspired building. Oddly enough, the *Grand Rapids Press* had an ad the day following the plant's closure that touted Fox Deluxe beer as "Michigan's most cheerful beer."

The Fox Deluxe Brewing Company building was purchased by the City of Grand Rapids in 1954 for $160,000. George Welsh, the city manager at the time, proposed using the building as the new county jail, but he was defeated in a vote. Another set of planners proposed using the site as a rehab clinic. Ultimately, it was only used occasionally by a few city departments, including the Grand Rapids Police Department, which used it as a garage and pistol range.

Grand Rapids lost several of its great buildings in the 1960s, including the former city hall and the Grand Rapids Brewing Company building. The urban renewal phase of Grand Rapids took the brewery down in 1964, following more than a decade of brewing absence. The Kent County Building now stands where the brewery proudly looked over much of the city.

In 1988, it was reported that the construction of the Kent County Building, now sitting on the famous Kusterer Spring, had stopped the crystal-clear water

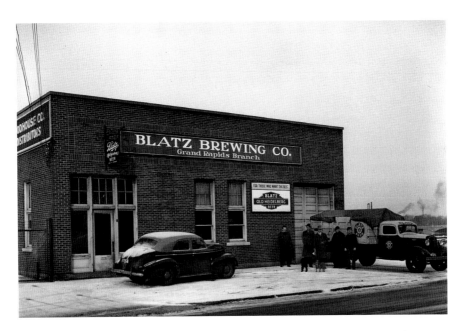

A Blatz Brewing Co. distribution warehouse, a sign of invading out-of-town breweries pushing local operations out of business. *Courtesy Grand Rapids Public Library.*

from running. If the spring still exists, no one knows, as the water would be filtered through and pumped through a sump pump into the city's sewer system.

Following the closures of the 1950s, West Michigan was left dry in the brewing world. Beer consumers in the region went the same way as the rest of the country as the population chose to consume mass-produced lagers. Anheuser-Busch rode Budweiser to a national supremacy following a long battle with Pabst and Schlitz, which were reinvesting similar money to grow their production, distribution and advertisements. Blatz operated a distribution center out of Grand Rapids, as well.

Those breweries continued to grow throughout the twentieth century, growing their existing facilities, building new ones, acquiring other breweries and making their products the beer of habit, not choice.

West Michigan was excited when Coors came to Grand Rapids in the middle of the 1980s. By the 1980s, homebrewing was a growing hobby and led consumers to the realization that there was more out there. Coors, still a very large but regional brewery, offered consumers a change that was sought after years of the same. At roughly the same time, Larry Bell was getting his start at Kalamazoo Brewing Co., starting the craft trend West Michigan would embrace in the years to come.

LAKESHORE ROUNDUP

Grand Rapids wasn't the only area city to have a nineteenth-century brewing operation. Muskegon Brewing Company was the longest-running singular brewing entity in West Michigan, surviving from 1877 to 1957.

It operated on Brewery Hill on Lakeshore Drive, where Cole's Bakery is currently located. The factory helped several other breweries through tough times, including bottling for Grand Rapids Brewing Company from 1935 to 1946 and Goebel Brewing Company from 1946 to 1957. Following Prohibition, it was also one of two places in the United States to bottle Guinness.

Machinery from the brewery was still in some of the Cole's Bakery building basements, until some of that equipment was purchased by Pigeon Hill Brewing Company in 2013. This equipment eventually will be used and displayed, depending on its condition.

Otto and Gustav Meeske were looking to get into the beer business in 1876 and purchased a small brewery called Neumeister. Before long, a partnership was formed with Gottlieb Ninnemann, and the name of Muskegon Brewing Company was decided. The facilities were expanded upon as demand increased. In 1905, the brewery made a significant addition, building a dedicated power plant, one of the first in the nation dedicated to a brewery. In 1915, the owners installed an ice plant, producing ice for the brewery but also for sale under the name of Pure Ice Company.

Muskegon Brewing Company brewed more than twenty thousand barrels of beer a year at its height while also making more than twenty-

The Muskegon Brewing Company owners, the Meeskes, pose outside the company's office in 1906. *Courtesy Michael Brower.*

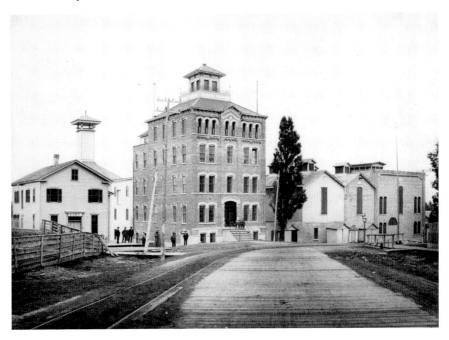

The Muskegon Brewing Company new brewery on display in 1884. *Courtesy Michael Brower.*

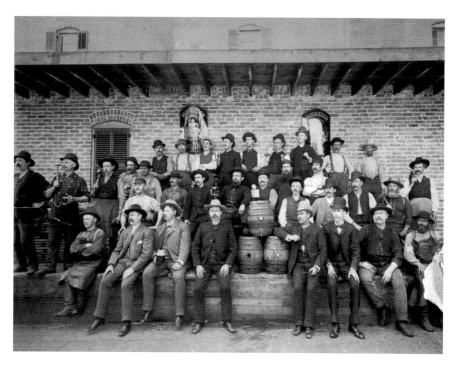

The Muskegon Brewing Company employees of 1887 pose around barrels, some while drinking mugs of beer. *Courtesy Michael Brower.*

five thousand bushels of its own malt, which "insured [*sic*] good and uniform color."

Ninneman had moved to the United States in 1854 and Muskegon in 1877, serving on a variety of public boards, including the Muskegon City Council. Otto Meeske came to the United States in 1871, spending several years in a brewing operation elsewhere. Gustav came to the United States a year after his brother, spending time in Milwaukee prior to landing in Muskegon.

The brewery produced porter and lager and quickly made a jump from five hundred to twenty-four thousand barrels.

During Prohibition, the brewery survived thanks to the company's ice subsidiary, Pure Ice Company, and by bottling nonalcoholic beverages, including Orange Crush, Blue Bird and Hires. Following repeal, the operation expanded and upgraded its existing breweries to house a large demand.

Included in the post-Prohibition expansion was a large contract with the United States government to brew beer for the U.S. Armed Forces. That contract was held over as the Grand Rapids Brewing Company, led by Frank McKay, purchased the brewery. The Muskegon brewery became one of the

major suppliers of beer for the U.S. Army during World War II. Under the Grand Rapids Brewing Company were the brands Hi-Brau Beer, the ever-popular Silver Foam, Lake State, Best and Genuine Old Lager. The nation's major brewers like Schlitz, Pabst and Anheuser-Busch also obtained armed forces contracts, and their much more extensive distribution networks and branding led to their being the beers of choice of returning soldiers.

Following World War II, Detroit's Goebel Brewing Company bought the plant and remodeled it. In 1955, Goebel obtained the agreement to brew Guinness, producing seven-ounce "pony" bottles of the Irish staple. It was one of a few breweries in America to produce Guinness. Goebel ceased operation in 1957.

When the brewery shut down in 1957, the prior ownership was involved in a lawsuit. Grand Rapids–based Laurent K. Varnum represented Anaconda Wire Coating plant as it was being sued by the Muskegon Brewing Company for $5.5 million claiming that the wire company's fumes contaminated the beer and forced the closure.

The case never went to trial, as the president of the brewing company was deposed and cross-examined by Varnum. The examination took five days.

Holland, too, had a pre-Prohibition brewery history despite a strong temperance atmosphere for most of its history. A brewery was started in "Tulip Town" in 1863 by J. Aling, near the original downtown of the city near the peninsula. Aling's brewery was up to one thousand barrels of production in 1869 and stayed there until it was destroyed by a fire on October 9, 1871. The fire destroyed much of Holland, including sixty-four stores, six churches, three newspaper printers, three hotels and more than two hundred houses. A series of fires were caused on that day by forest fires, some likely propelled by the Great Chicago Fire.

As Holland rebuilt its infrastructure, the city was without a brewery for two years until C. Zeeb, a brewer from Milwaukee, opened a brewery on Tenth Street and Maple Avenue. In Zeeb's first year of production, he produced 450 barrels of beer before selling to E.F. Sutton and J. Steiner. Sutton bought Steiner out in 1875, and he had intentions of growing the production so the city wouldn't need to import beer from Milwaukee and the Netherlands to satisfy the ever-growing demand.

Sutton paid off all his debt and expanded his production. As did many of the other breweries of the day, he promoted his beer as at least equal to those coming from lager haven Cincinnati.

Zeeb was back in the picture when he and Anton Seif purchased the Holland Brewery from Sutton in 1879. Seif was also a Milwaukee-trained

brewer and eventually found himself the sole proprietor of Holland Brewery, increasing the company's production to 1,500 barrels in 1886 and up to 4,000 barrels.

As with other breweries in the nineteenth century, ice was needed from natural sources. According to the *Holland City News*, Seif took ice from Lake Macatawa, using bobsleds and horses to get the ice from the lake back to the brewery and store it in an icehouse.

Holland City Brewery changed hands a few more times, first in 1895 and back to Seif in 1898. The brewery, and its Prohibition-era cheese operation, didn't survive past the 1920s, like most Michigan breweries.

Part IV

Present-Day Breweries

CHAPTER 10
GRBC

Following a push at the state legislative level in 1992, laws were changed to allow for brewpubs and microbrewers in the state, allowing for the still young and immature brewing world to really gain traction in Michigan. A statewide restaurant ownership group called Schelde Enterprises saw the opportunity of brewpubs to be irresistible, and small brewers saw a 44 percent nationwide growth, while the overall beer industry was stalling. With those national numbers in hand, Schelde turned one of its Grand Rapids restaurants, Jose Babushka, into Grand Rapids Brewing Company, doing its best to make it look like a turn-of-the-century brewery in honor of the pre-Prohibition success of the operation of the same name. With the freshly minted legislation, Grand Rapids Brewing Company was awarded the second brewpub license in Michigan. Staying true to the name's heritage, the brewery began to produce Silver Foam, the pre-Prohibition lager that saw nationwide success.

Prior to the brewpub's opening on November 3, 1993, brewer Mark Stehl told the *Grand Rapids Press* that Grand Rapids Brewing Company "won't be serving the familiar brands pitched by former athletes or pulled by Clydesdales." Among the first brews were Black Dog Ale, River City Red, Silver Foam and Thornapple Gold.

Stehl had started in Schelde as a wine steward, while homebrewing in his spare time. With the homebrew experience in hand and the brewpub opening up, Stehl was placed in charge of the seven-barrel copper brew system. Stehl had confidence in his brewing skills and was sure the

company would help transition beer fans and be a harbor for the growing homebrewing community.

"I don't want our staff saying this is like any other beer," Stehl told the *Grand Rapids Press.* "It's kind of a subculture. There are a lot of people who make their own beer. The brewpub opening might bring them all to the forefront. They can swap techniques and ideas at the bar over a River City Ale."

Stehl left the company in 1998, when John Svoboda took over as head brewer. Svoboda had been a science teacher during his first life and decided life would be better as a brewer. He began brewing in 1986 and applied for a job at Grand Rapids Brewing Company in 1993, bartending and helping around the brewery part time.

Svoboda left in 2007 to become brewer at B.O.B.'s Brewery in downtown Grand Rapids.

Schelde continued to operate Grand Rapids Brewing Company with continued moderate success until 2010, when it sold to John Ljuljduraj and Mark DeHahn. The pair did not renew the lease with the owner of Centerpointe Mall, where the brewery was located, and the brewpub closed in June 2011. The assets of the brewery reverted back to Schelde Enterprises when it closed, but the group sold the rights and equipment to modern bar baron Mark Sellers, who implemented plans to move the brewery back downtown.

"It's a great brand and it's been mismanaged, in my opinion, so I thought if I could move it to a different location and really focus on rebuilding that brand it could be successful," Sellers told the *Grand Rapids Press* in 2011. "I see basically zero brand equity right now. It will be really easy to get people to realize it's different now. They don't have a horrible, horrible reputation. They just have no reputation."

CHAPTER 11
THE FIRST WAVE

In the middle of the 1990s, Jim Roffey was working as an engineer at the Boeing Company in Seattle, helping make some of the world's largest airplanes. But in the middle of the home of the nation's early microbrew movement, Roffey decided it'd be fun to open a brewery. To open another brewery in Seattle, however, didn't seem like a smart idea, as the West Coast was full of breweries and close to what many thought was a limit of beer producers.

With the idea fresh in his head, Roffey moved to his wife's hometown of Holland, Michigan, a place in the middle of America and far from the coasts where craft beer was big. He thought he'd open up one of the first breweries in West Michigan and be a pioneer.

Little did he know he was one of many thinking of starting a brewery. Four other potential brewery owners were fresh out of college, looking to get their start in the world of brewing; two paired with a future brewery in Holland; and another two prepped for an opening in Grand Rapids. Another two were bankers and decided to break out with a brewery on the outskirts of Grand Rapids.

All seven borrowed between $500,000 and $800,000 to get their operations up and running. The times were tough for potential brewers, and lenders were wary since there were no real signifiers that the operations were successful or in demand. The beer market was stalling, despite a growth in the small beer producers segment, so it didn't seem like a great idea to open a brewery that would compete with the massive brewers that had

come to dominate the market with advertising dollars and a plain product. The Brewers Association warned at the time that 1 out of every 7 breweries failed, and in 1997, 60 of the nation's 1,300 breweries went out of business.

Still, Roffey was the first of the four breweries to open up in 1996, expanding during several years and taking shelf space in many Holland stores for its beers. Eventually, the Roffey Brewing Co. made its way to some statewide distribution.

Michigan's lakeshore was at the heart of Roffey Brewing Co., as noted by the brewery's beer names like Forecaster Pale Ale, Wheat Wave Ale and Lake Effect Stout.

Meanwhile, in Grand Rapids, Robert Kowalewski and Thomas Prame were setting up shop at 2600 Patterson Avenue, near an ice arena. Prame and Kowalewski had met while they were in the MBA program at Notre Dame, and both went on to work at Old Kent Bank. Deciding they needed a way out of that world, they started putting together a brewery plan during nights and weekends. Before long, they had put together approximately $700,000 through a bank loan and thirty-three investors.

Along with their brew system, Prame and Kowalewski set up shop with three sixty-barrel fermenters, a twenty-barrel fermenter and a bottling line. Initial plans for Robert Thomas Brewing Co. were to brew four thousand barrels of beer a year and sell in kegs and six-packs for $6.99.

Prior to Robert Thomas's opening in 1998, brewer John Tully explained the craft beer trend to the *Grand Rapids Press* and blamed Prohibition for the demise of flavorful beer.

"Before Prohibition, brewers made a local, fresh and quality product," Tully said. "Beer became less bitter, less hoppy and lost complex flavors."

Tully's attempt to buck the light lager trend was by making beers such as Par Five Pale Ale, King's Cross Porter and a hefeweizen. Tully had worked at Baltimore's DuClaw Brewing Company and moved back to Grand Rapids when he learned his childhood classmate from East Grand Rapids, Kowalewski, was opening up a brewery. His job was to create beers that would attract fans and keep them coming back.

"Taste is the first thing that draws people to a microbrewery," Prame told the *Grand Rapids Press*. "What will draw people to Robert Thomas is concrete evidence where people go to a brewery, meet the brewers, see how the product is made and taste the raw ingredients and finished product."

By the time Robert Thomas opened its doors, Roffey Brewing Co. had been open for more than a year, and Jim Roffey had a warning to other breweries opening, telling the *Grand Rapids Press* that a good product isn't

enough to keep a brewery open in the competitive market place. At the time, very few bars and restaurants were opening up tap lines to the new breweries, as their products weren't selling.

"I've got 30 beers and the locals are the bottom six in sales," Mark Weier, the general manager of a bar called Tap's Sports Bar, told the *Grand Rapids Press* in 1998. The establishment had twenty-nine taps, then a large number for a bar. "I say, 'Hey, I'd like to be supportive, but people just aren't drinking your stuff.'"

By 2001, Roffey Brewing was struggling, and history was set to repeat itself as a merger was looming. The brewery moved inland and was integrated into the Robert Thomas Brewing operation in July 2001, despite brewing roughly one thousand barrels a year. The merger placed Robert Thomas at the top of the Grand Rapids brewing industry as it pushed out nearly two thousand barrels a year.

Roffey maintained a share in ownership of Robert Thomas and served on the board but worked at Zeeland-based Innotec. His decision to sell the Roffey Brewing brand was based on a desire to commit more time to his family, according to an article in the *Holland Sentinel*.

"It has nothing to do with the Holland area. I'd love to stay in Holland—I live here—but it made sense from a business standpoint," Jim Roffey said in the *Sentinel*. "I have two little kids now and so my priorities had to change. I couldn't give the brewery the attention it deserves."

Roffey brewer Michael Bowe continued making beer at the Grand Rapids location. The brands remained separate, and the Roffey beers continued to be sold at accounts. The breweries were separate for the most part, just operating under one roof. "It allows us to increase production and gain cost efficiencies versus having the overhead of two companies for two brands," Kowalewski told the *Grand Rapids Business Journal*.

Robert Thomas also was the parent of Michigan Soda Factory, which was making and bottling five flavors of soda, including root beer, cream soda, orange cream soda, black cherry and wildberry.

Kowalewski told the *Business Journal* the move was part of a growth strategy, explaining that the industry wasn't growing at the pace it had in the past. Instead of investing more capital into internal growth, Robert Thomas went with acquiring an already operating and established brand. Kowalewski worked full time as the salesman for the brands, and Prame worked during his off hours, but he was working full time at Fifth Third Bank. Several Michigan brewers became seasoned brewing professionals following their time at Robert Thomas. Scott Isham worked at Robert

Thomas before moving to Harper's Brewpub in East Lansing, where he has been since 2000. Kim Kowalski had his first head brewer job there as well and won two United States Beer Tasting gold medals for a stout at Robert Thomas. He later moved on to Bell's Brewery and finally into a head brewer role at Mountain Town Station in Mt. Pleasant.

"The growth [in microbrewing] is still there, but it's slowing down a bit," Kowalewski told the *Grand Rapids Press* at the time. "Together we can grow. We would love to be a strong regional brewery."

By 2004, however, Robert Thomas Brewing Co. hadn't made enough of a solid foothold in the Grand Rapids and Michigan markets and decided to shut its doors.

SHORTLY AFTER THE Van Andel Arena opened up on Fulton Street in downtown Grand Rapids in late 1996, a plethora of new bars and restaurants popped up to support the large crowds drawn to the sporting events and concerts.

In 1998, a brewery opened with its doors less than two hundred feet from the entrance of the arena at 25 Ottawa Avenue and was aptly named Arena Brewing Company. The brewery played into the old factory setting, with three slightly rusty garage doors and a rusty steel bar capped with a concrete slab and brick walls and floors.

The brewpub was an extension of Schelde Enterprise's restaurant management empire, which had recently decided to tap into the trendy microbrewing world. The first was the transformation of Jose Babushka's into Grand Rapids Brewing Company, followed by Ann Arbor's Grizzly Peak Brewing Company and Traverse City's North Peak Brewing Company.

Referring to the Arena Brewing Company, however, Schelde vice-president Barry Haven told the *Grand Rapids Press* that it was the most radical project the company had undertaken. Arena Brewing Company offered up six to eight of its own beers, including several pale ales, a porter, a Dortmunder export and a seasonal saison to go along with an eclectic menu of pizzas, sandwiches and salads.

Ron Jefferies and Alec Mull, two well-respected names within the Michigan beer world, were at the helm of the brew system during the brewery's short existence. Jefferies is a world-renowned brewer with Jolly Pumpkin Artisan Ales, and Alec Mull is director of brewing operations at Founders Brewing Co.

Packed when Van Andel Arena attracted crowds to the district, Arena Brewing Company wasn't enough of a draw on its own and struggled to fill its taproom on other nights. With the inability to fill the restaurant every night, the company chose to shut its doors, telling several publications the

brewery might open in the future following a review of the situation. The reopening, however, did not happen, and the space was vacated. Every operation that's been in that space since has had trouble lasting more than a few years.

Across the street from Van Andel Arena and the building Arena Brewing Company briefly called home is the B.O.B., or Big Old Building. The B.O.B., opened in 1997, is a complex in a former grocery warehouse and is now made up of a variety of restaurants and bars, including B.O.B.'s Brewery in the basement of the brick warehouse.

Armed with brewer Dennis Holland and a fifteen-barrel Pico Brewing System, the brewery in the basement makes a variety of beers, such as Festive Amber, Happy Pilsener, Pale Ale and B.O.B.'s Lager.

The B.O.B.'s brewery started as a small piece of the giant entertainment building's puzzle, but as the years have gone by and craft beer becomes more prominent, especially in Grand Rapids, the building's owner, the Gilmore Collection, has grown the brewery to fit its demand. In 2007, following Holland's departure, Greg Gilmore called Grand Rapids Brewing Company head brewer John Svoboda and offered him the role as head brewer at the downtown brewpub.

Since Svoboda joined the team, the brewpub has grown from a corner of the building's basement to incorporate the entire lower floor in 2013. As a staple in the Grand Rapids brewing industry, Svoboda has pushed the limits in the B.O.B. while trying to keep beers on that every person can enjoy. His beers are served at the restaurants and bars throughout the building. He keeps three beers on tap at all times: Blondie, Crimson Kin Amber and Hopson Wit in the summer and Spaceboy Stout in the winter. The brewery's other nine taps are for more experimental beers, like his peanut butter stout.

He's also implementing a more focused approach to combining food and a beer, a growing trend in the whole industry, but Svoboda's focus goes back to his time at Grand Rapids Brewing Company. The brewery regularly does more than six hundred barrels in a year and is primed to keep growing its output should demand call for it.

CHAPTER 12
THE SHOP THAT STARTED IT ALL

The reason the craft beer industry in Grand Rapids has grown so quickly with impressive passion and quality is unknown, but there's a good chance it has at least a little something to do with a small shop on Lake Michigan Drive.

Steve Siciliano bought a party store in 1993, called Paul's Pour House, and it wasn't going terribly well. Attempting to do anything he could to make the store a success and bring in clientele, Siciliano started offering unique beers most other stores in the area wouldn't even glance at. He said business continued to sink for five years following the initial purchase, and sometimes up to three hours passed between customers.

"I wasn't doing well. I had to be innovative and look for things to turn it around," he said. "So I started getting these beers no one else had."

Then he started splitting the packs into singles and allowed customers to make their own six-packs. Seeing an increase in customers looking for these unique, flavorful beers, he took another step. He invested $300 in homebrew supplies to keep the beer community coming in the door.

"It was scary in a sense that I had to invest $300 I didn't have and thinking, 'Is this $300 I'm just throwing away?'" he said.

Siciliano bought the 7-Eleven store he ran in the 1980s to escape from the corporate world as a traveling marketing professional. The 7-Eleven store cost him $10,000 altogether—including $5,000 on inventory—but it helped him become part of the community. He upgraded to his own convenience store in Creston Heights, but a lack of market for the fine wines he loved necessitated an upgrade.

"I really enjoyed being a part of a community, and back then, 7-Elevens really were," he said. "I learned a lot from that experience: customer service, how to run a business. Anyone who can get through that can get through anything."

He's back to the heart of a community in Grand Rapids, thanks to the initial $300 he invested in homebrewing. On a busy day now, he'll see more customers than he saw in a week back in the 1990s. He eventually bought the space next to his original shop and added more homebrewing supplies and now maintains more than one thousand square feet of dedicated homebrew retail space.

"That really started putting us on the map," Siciliano said. "It wasn't like I was trying to start a new business—I was just trying to supplement."

Now as Grand Rapids continues to become more recognized for craft beer, many of the brewers contributing to that reputation started with a stop at Siciliano's Market.

Jacob Derylo, head brewer at Brewery Vivant, is Siciliano's nephew and started homebrewing while working at the shop. Other names include Chris Andrus, Max Trierweiler and Jason Warnes from Mitten Brewing Co.; Bill White of White Flame Brewing Co.; and Seth Rivard of Rockford Brewing Co. Many more cut their teeth with supplies from Siciliano's.

"It's tremendously cool," Siciliano said of all the brewers who started as his customers. "I don't want to take too much credit for it, but the brewers came in here and I got to know them all. A lot of these guys were customers, and I got to know them on a first-name basis.

"We have a real solid homebrew community. It's incredible what's going on. Craft beer is exploding. There's a synergy: the more homebrewers there are, the more breweries there are—they feed off each other."

Siciliano is a major supporter of all the breweries in the city, regularly making stops at each one, sampling beers and chatting with his former customers. He continues to host an annual homebrew contest and started an annual Big Brew Day at Calder Plaza in Grand Rapids, beginning when the city found out it would host the 2014 American Homebrewers Association Conference in 2013.

He might now leave at noon some days, but Siciliano is still trying to expand the opportunities of the store. He launched Siciliano's Market Press, a way to publish home-brew recipe and history books.

In 2013, and again in 2014, Siciliano's Market was named RateBeer.com's Best Beer Grocer in the United States. Siciliano is quick to concede that there are better beer and homebrew shops out there, but he'll always strive to be better.

"I want to continue to be highly regarded—that's important," he said. "It was like the [customers] won the Super Bowl, and for that reason, I feel like we have a responsibility to keep doing what we're doing for them."

Now, if a Grand Rapidian is a craft beer fan, they likely know Siciliano's Market, with its wide variety of U.S. and international brews, spirits and cigars. And if they're drinking a beer at one of the local breweries, chances are the brewer got his or her start browsing the aisles at Siciliano's.

CHAPTER 13

A BRIEF HOPE

Right around the time Grand Rapids Brewing Company was serving its first beers, four of West Michigan's modern beer pioneers were finishing up college and putting together an alternative life plan, at least compared to their classmates. It might seem odd, but three of the most widely known and recognized breweries in West Michigan started from a single fraternity at the dry Hope College in Holland, Michigan. In the early 1990s, a few years after Larry Bell had started Kalamazoo Brewing Company, which later would become Bell's Brewery, Mike Stevens, Dave Engbers, Brett VanderKamp and Jason Spaulding were kicking around at the Omicron Kappa Epsilon fraternity.

Fresh out of college, Stevens and Engbers would go on to start Founders Brewing Co., and VanderKamp and Spaulding founded New Holland Brewing Co. Spaulding would later split from New Holland and eventually open Grand Rapids' Brewery Vivant.

"Our fraternity did love beer," Spaulding said. "Hope did not promote starting breweries out of college, but stars kind of aligned and we kind of egged each other on in the early days."

Stevens was a few years older than the other three and left school a credit shy of a degree. His several attempts at starting a business had failed, but he and former classmate Engbers were homebrewers, and with Engbers unhappy in his teaching job, the two decided to go for it. Stevens spent a year at the library learning the different aspects of business and writing a

business plan. Before long, the pair had enough capital—at least what they thought was enough—to start the brewery.

Spaulding and VanderKamp thought of the same idea around the same time. They recalled a "legendary" business plan written by their former classmates. At the time, much of the New Holland Brewing Co. plan was already set in place, but the new brewery owners wanted to make sure they were on the right track. Stevens remembers the exchange differently, thinking Spaulding and VanderKamp took much of the business plan to heart. But Spaulding said it was just a cross-check.

"We were like sponges, taking ideas and leads from everywhere we could," Spaulding said. "We sought it out, and they were cool enough to show us what they had done. After reading their plan, we determined that we just needed to stay the course with our own thoughts in our own voice, so it did not really change in direction afterward."

Stevens handed the business plan over with the stipulation that the breweries would stay in different cities, New Holland in Holland and Founders in Grand Rapids.

New Holland Brewing opened its doors a tad earlier than Founders in early 1997. Both have taken extraordinarily different paths to where they have ended up, with Founders reaching further with its beers, but New Holland ventured into a whole new market: distillation.

Spaulding ended up leaving New Holland in 2005 in hopes of exploring new ventures, and in 2010, he opened Brewery Vivant in the backyard of the rapidly expanding Founders. Spaulding sought out various cities, and before settling on Grand Rapids, he made sure to sit down with his old fraternity brother to make sure it was OK that he ended up in Grand Rapids. Many established brewers are weary of startups, because subpar beer could hurt the industry, but Stevens knew the beers Spaulding would end up making would help the industry.

"He called to grab lunch and wanted to do the right thing and be upfront and honest," Stevens said. "Honestly, it only builds the industry when a good guy—a guy who knows what he's doing—starts up."

With four brothers from a single fraternity coming out of the school, Hope College does do some collaboration with the industry, but it's not widely promoted.

"They really put their education in business, art and science to use in a unique way," Hope College director of alumni and parent relations Scott Travis said. "It's nice to be able to reference them as successful business owners, and we are proud of them."

The school retains many of its graduates in the Grand Rapids area, and Travis said more than six thousand alumni contribute more than $76 million to the economy, plenty of which comes from the three breweries.

"We were drinking, doing what college kids do," Stevens said. "But that frat bred a lot of entrepreneurs. Look around Grand Rapids, and you'll be amazed at how many there are."

CHAPTER 14

NEW-AGE FOUNDERS

Walk into an office of Dave Engbers or Mike Stevens, and it's a laidback feeling, with music, from island music to '80s hair metal, always playing quietly in the background. The pair is at the front of one of the nation's fastest-growing and most well-respected breweries in the United States. Sit down for a beer with one of them, and there's no sense that they've changed in the nearly two decades they've run the company.

It likely has a lot to do with Founders Brewing Co.'s first decade in business. The decade kept them grounded, knowing a business isn't guaranteed to be a successful endeavor. All the success in the world won't let Mike Stevens forget what it took to get there.

"I love our story. I love to look at it, and there's a bit of victory," Stevens said. "If you said, 'Would you do it over again?' I would actually say, 'No.'"

The brewery started in 1997, after years of talking about and planning the business. Stevens and Engbers picked a spot in a redeveloping part of downtown Grand Rapids on Monroe Avenue, in the Brass Works Building.

Monroe Avenue was once named Canal Street, a part of town several breweries called home in the late 1800s. Brass Works is a stone's throw from where Christoph Kusterer built his home and brewery. The brewery was the first business in the building since the brass worker left in 1986.

Research taught the new business owners about the rich brewing heritage of Grand Rapids and led them through several names, including their LLC name, Canal Street Brewing Co., and, of course, the name that's made them famous: Founders.

Founders Brewing Co. was the first tenant in the Brass Works Building on Monroe Avenue since the brass worker left in 1986. *Courtesy Founders Brewing Co.*

A look at the interior of the Brass Works Building before Founders Brewing Co. moved in. *Courtesy Founders Brewing Co.*

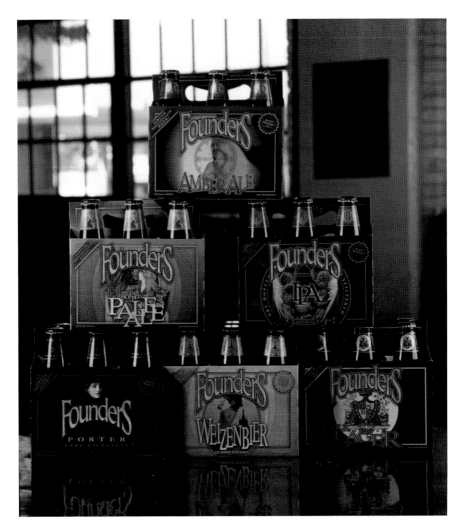

A stack of early Founders beer six-packs, including three styles no longer produced. *Courtesy Founders Brewing Co.*

Craft beer in the early years was driven by simple styles that offered light alternatives to the mass-produced lagers. Early beers at craft breweries often included pale ales, wheats and ambers. Many of the beers tasted good but weren't standouts when compared to one another.

Engbers often refers to Founders' operation at the time as making "well-crafted, unremarkable beers." These brews contributed to early struggles from many craft breweries and ultimately didn't pull many consumers away from the light lagers they were familiar with.

They thought their beers would appeal to a wide market, but instead this philosophy left them with fewer customers buying enough beer for the brewery to survive.

Early on, Founders faced a lawsuit from a fellow Grand Rapids brewer, Robert Thomas Brewing Co., which sued Founders for claiming its beer was made in Grand Rapids when it was being contract brewed in Minnesota. The brewery was slow to be renovated, and the partners needed to make beer, so they made thousands of bottles of pale ale in Minnesota.

"We've never tried to mislead the public," Stevens said in a *Grand Rapids Press* article on April 4, 1998. "We're just trying to sell beer."

The case was settled when Founders stamped the six-packs with a statement explaining the beer was made in Minnesota.

Once the new millennium hit, Engbers and Stevens were struggling to stay afloat. Credit cards were opened regularly trying to make ends meet. Payments were missed regularly. The banks started pressuring the pair to succeed or get out, with the ruined financial record to their names. Stevens said if they had a way out that would have left their names and lives relatively intact and safe, they would have taken it. But that wasn't an option, and the world was much closer to losing Founders Brewing Co. than many think, even after hearing the tale of Engbers's bolt cutters.

In 2001, the bank, upset that the brewery was so far behind on payments, decided it was time to pay up. Engbers went to a hardware store and bought a pair of bolt cutters. He figured if the brewery's doors were chained shut, he would cut them open and work like nothing happened. The pair concede now that the brewery was undercapitalized from the beginning—about $350,000 from various sources—which led to poor financial management and stretching for ways to come up with money. At the low point in 2001, the brewery owed roughly $550,000.

A meeting with investors led mostly to dead ends, except for a call from local businessman Peter C. Cook. He met with Engbers and Stevens, mostly talking about beer. Cook left that day without any indication he was going to help Founders make it past the troubling times.

The next day, the bank informed Engbers and Stevens that Cook had guaranteed their loans.

"The dark days were a lot darker than people think," Stevens said. "If Founders ended today, and I had an opportunity to start again tomorrow, and they said the life cycle would be the exact same as Founders, I would say, 'No, thank you.'"

"I'd wager to bet, if we had a way out, we would have taken it. We had personal guarantees in loans, our wives signed, we had second mortgages. There was no other option than to succeed."

Engbers echoes his partner's statement.

"You don't want to sound like one of those people who say, 'When I walked to school, I walked through five miles of ice uphill,' but that's pretty much what we did," Engbers said. "But really that was it. It was working eighteen- to twenty-hour days every day, broke as you can be, zero money, no friends."

Near the same time, Engbers and Stevens talked about what to do next. With the business in danger of closing by making beers they weren't all that passionate about, they decided to brew beer they wanted to drink. Soon the tagline for which they became known far and wide was coined: "Brewed for us. Enjoyed by everyone."

With the loan guaranteed by Cook, Founders started to kick it into gear. Still, Stevens said the brewery lost money for several years. With new brewers Nate Walser and Jeremy Kosmicki at the helm, the beers that make up the brewery's stable began to develop, such as Centennial IPA, Breakfast Stout and Dirty Bastard.

"It took us some time to figure out selling one beer to one hundred people doesn't work," Stevens said. "But selling ten beers to twenty people works. We narrowed our focus to beer geeks. They were the passionate ones, the people who care about beer. They were the ones that were interested, intrigued and spread the word."

The word spread quickly, as beers such as Dirty Bastard showed that strange beers that defied the light beer mentality of many Americans could make a dent in the beer market.

With the shift in the brewery's mindset, its reputation grew. Before long, Founders was continually ranked as one of the best breweries in the world. With the reputation growing, so did demand and the need to expand. The first such expansion took place in 2006, when the taproom shut down for a few days as it put about $50,000 into renovations to help make the brewery more comfortable to patrons. Prior, an attempt to move to a building on Ionia Avenue had fallen through, necessitating this action. The project also included an expanded kitchen so customers could fill their stomachs with food, allowing for more beer consumption. The Brass Works lease was also extended shortly before that expansion, which included more production space. With the new space, Founders brought in new fermenters that could help double the production to eight thousand barrels a year.

"It's really going to allow us to kind of proof the business out, so to speak. We've got two more years on this lease," Stevens told the *Business Journal* in October 2006. "In those two years, we will really be able to ramp up our production, and then probably make a move once this lease is done. That's the plan."

The plan worked quicker than anticipated, and in 2007, Founders needed to move to a bigger space to accommodate future growth plans. The Brass Works Building could have had a cap of about ten thousand barrels per year, but when the brewery left the space, it was at six thousand barrels. The brewery found an old truck depot on the other side of town at 235 Grandville Avenue with enough space to accommodate forty thousand barrels. The 8,500-square-foot former depot was renovated to become the taproom and offices. About 10,700 square feet of production space was added to the property. Foresight was key, as a plan was set to be able to expand the space another 10,700 square feet when needed.

The move allowed Founders to grow at an almost unprecedented rate. From 1997 to 2006, the brewery only produced more than 4,000 barrels annually near the end and employed approximately ten people. In the

235 Grandville Avenue when it was a truck depot. *Courtesy Founders Brewing Co.*

The inside of Founders Brewing Co.'s new taproom at an old truck depot on Grandville Avenue, prior to a 2013 renovation. *Courtesy Founders Brewing Co.*

company's last year at the Brass Works Building, it produced 6,127 barrels. Then growth came quickly. Founders brewed 11,898 barrels in 2008, sending it to seven states.

The next year, production spurted up to 17,330 barrels with fifty-four employees. John Green of Locus Development joined Founders as a partner, as he and his Locus partner Andy Winkel were crucial in the move to 235 Grandville Avenue. With seventy-one employees in 2010, Founders brewed 24,501 barrels of beer. In 2012, Green became the company's president, with Winkel taking the reins as CFO.

Following a year where it reached capacity in its new building and was named RateBeer.com's No. 4 brewery in the world, 2011 saw Founders undergo an $8 million installation of a new brewhouse and a new bottling line, upgrading from forty bottles to two hundred bottles per minute. The line was a cap on the expansion that more than doubled production capacity with the installation of 250-barrel fermenters. A $1.4 million upgrade to the brewhouse came the following spring. The upgrades in 2011 saw production increase to more than 45,000 barrels.

"Growth in our existing markets is ridiculous," Engbers told the *Grand Rapids Press* in 2011. "Our wholesalers almost laugh about it."

Founders helped start a major craft beer trend in 2011 when it first sold Endurance All-Day IPA, later shortened to All Day IPA. The session IPA clocked in at 4.7 percent ABV but full of hop flavor. Shortly following its release, All Day IPA rocketed to the top of the Founders portfolio, displacing Centennial IPA as its top-selling beer.

Stevens told the *Press* in that article, "If we ever get to a point where we have to change from that formula, I'd stop our growth."

Founders announced another $3.6 million expansion project in late 2012 that would add 165,000 barrels of fermentation space and a new brewing vessel. The expansion brought Founders' production capacity to about 320,000 barrels.

At the time, Stevens said the company was happy to have a financial partner that could keep pace. "Founders has become a capital-intensive business," he said. "We're fortunate to have a partner that can keep up."

In the midst of a $26 million expansion of the brewhouse, offices, taproom and beer garden, the company had to step back during a production bottleneck in June 2013. Rapid expansion caused downtime in production and slowed the brewery's intended moves of the year.

"Please know that these difficult moves affect many parts of our business, but should be done for both short- and long-term success," Founders communications manger Sarah Aldrich wrote in a release at the time. "Until we have built up core brand inventories in all markets again and are comfortable in meeting existing demand, these opportunities must wait a bit longer."

Part of the bottleneck was delaying shipments to Florida, a new market, and releasing All Day IPA in cans, the first beer to be canned by a Grand Rapids brewery. Centennial IPA was later also released in cans.

Founders distributes to more than thirty states with cans and bottles, including an innovative craft brewers dozen of fifteen cans of All Day IPA. The brewery continues to pair with Grand Rapids organizations, including sponsorship of the internationally recognized ArtPrize and the Whitewater project to restore the Grand River.

Founders opened a giant beer garden and taproom expansion in the fall of 2013, and Jeremy Kosmicki and his brewery crew continue to innovate with taproom beers and the limited-release Backstage Series. New beers don't stay limited release forever. In fall 2014, Founders released a new seasonal, Dark Penance Imperial Black IPA.

Founders rode into 2014 looking forward to growing into its larger space and looking further into the future after a rough 2013. More than 100,000 barrels were brewed in 2013, with an outlook of about 200,000 to finish out 2014.

Founders Brewing Co.'s new exterior after a massive renovation in 2013. *Courtesy Brewstravelers.*

"We had a pretty tough year, but it was positive turmoil," Stevens said. "All the construction, expansion and capital being invested in new machinery—everything is now in place and on the floor."

No matter how big Founders gets, Stevens and Engbers can look back on their journey and be proud of the Grand Rapids beer centerpiece they created through years of ups and downs.

"What Dave and I have been able to accomplish, we've done by sticking to our guns the whole way through," Stevens said. "It's a great victory, and it's cool. That's where our slogan 'Brewed for us' comes from. It truly is the last few years defining who we are. We never looked any way but inward to satisfy the beers we wanted to make, and we didn't pay attention to what the market was looking for or demanding. It's been cool to know that we've done it our way."

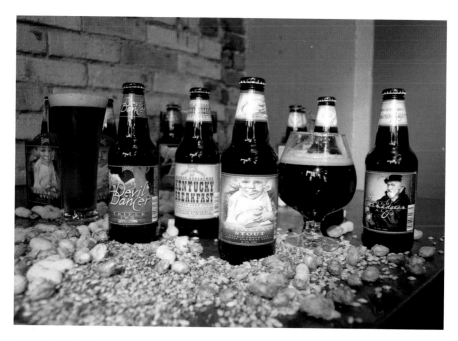

A look at Founders Brewing Co.'s portfolio, circa 2010. *Courtesy Founders Brewing Co.*

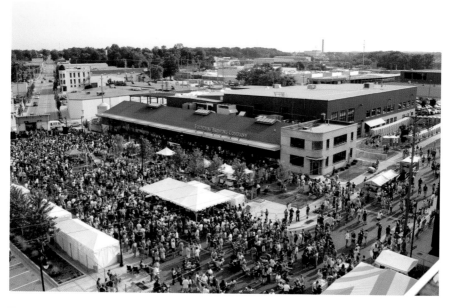

Founders Fest brings thousands of people to the exterior streets of Founders every June. *Courtesy Founders Brewing Co.*

New Holland founder Brett VanderKamp lost his shaggy hair from the early days as he poses at the Eighth Street pub. *Courtesy New Holland Brewing Co.*

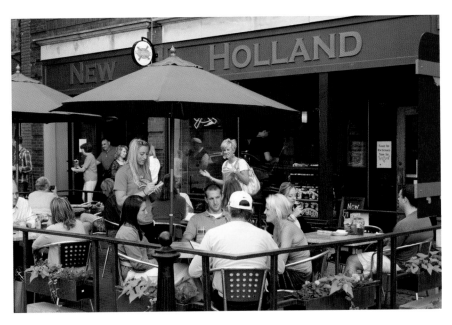

New Holland Brewing Co. is one of the busiest spots in downtown Holland, with outdoor seating in the front and back. *Courtesy New Holland Brewing Co.*

New Holland partner Fred Bueltmann released a book in 2013 called the *Beervangelist Guide to the Galaxy*, about the culture of food and beer. *Courtesy New Holland Brewing Co.*

Odd Side Ales releases a variety of limited edition four-packs along with its normal six-packs. *Photo by Bryan Esler.*

An Odd Side Ales bartender chats to a customer while a flight of samples awaits consumption. *Photo by Bryan Esler.*

The pre-Prohibition Grand Rapids Brewing Company logo is painted on a red door that hangs behind the bar at the Grand Rapids Brewing Company that opened on Ionia Avenue in 2012. *Photo courtesy Barfly Ventures.*

A customer sits at the bar of Harmony Brewing Co., a brewery that opened in 2012. *Photo by Damon Card.*

Harmony Brewing Co.'s pizzas have become well known across the city of Grand Rapids. *Photo by Damon Card.*

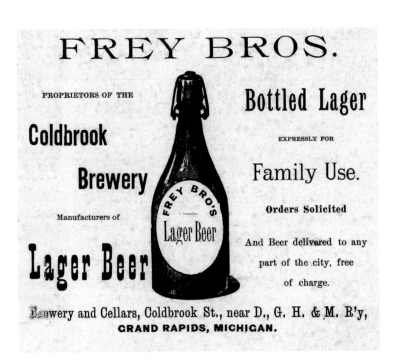

This Frey Bros. Coldbrook Brewery ad ran in a city directory in the 1800s. The lager was proudly described as a beverage suitable for family use. *Courtesy Grand Rapids Public Library.*

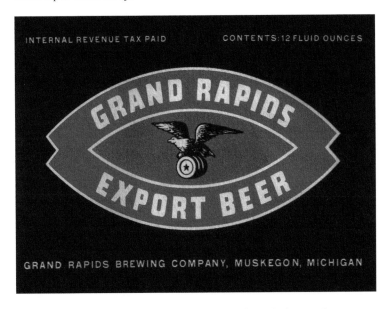

A Grand Rapids Brewing Co. Export Beer label from the brewery's post-Prohibition years when it was produced in Muskegon. *Courtesy Michael Brower.*

HopCat's brass towers are a statement meant to show the bar is beer-centric, owner Mark Sellers said. *Courtesy BarFly Ventures.*

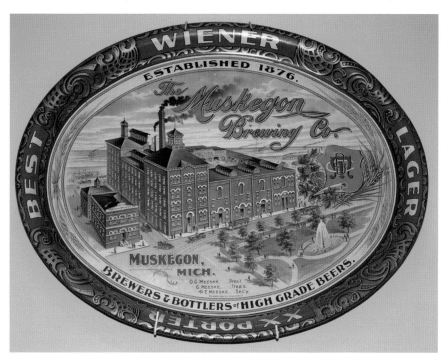

A Muskegon Brewing Co. tin plate. *Courtesy Michael Brower.*

A label of Hi-Brau Ale, produced by the Grand Rapids Brewing Co. during the company's years in Muskegon following Prohibition. *Courtesy Michael Brower.*

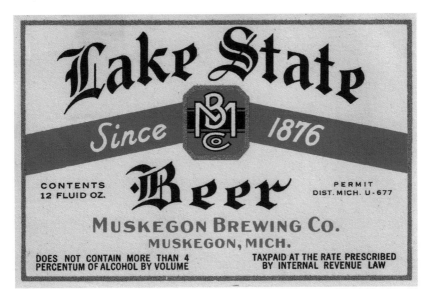

Muskegon Brewing Co. label of Lake State Beer. *Courtesy Michael Brower.*

The B.O.B.'s banners highlight some of the brewery's standard beers. *Courtesy Brewstravelers.*

The sour room at New Holland Brewing Co. *Courtesy Brewstravelers.*

The exterior of Brewery Vivant, a Belgian-Franco-inspired brewery opened in 2010, located in a former funeral home. *Courtesy Brewery Vivant.*

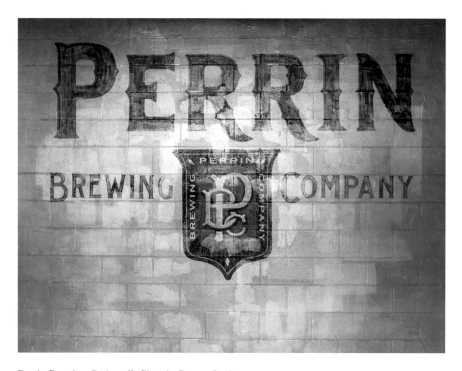

Perrin Brewing Co.'s wall. *Photo by Damon Card.*

Rockford Brewing Co. is located on the White Pine Trail, which helps promote the company's connection to the outdoor community. *Photo by Damon Card.*

Rockford Brewing Co.'s tap handles echo the interior of the building, even when they're out on the market. *Photo by Damon Card.*

Schmohz Brewery staple lineup in bottles. *Courtesy Schmohz Brewery.*

Brewery Vivant's food is nearly as well known as its beer. *Photo by Damon Card.*

Opposite, top: The Mitten Brewing Co. on Leonard Street, shortly following the opening of its porch in summer 2014. The brewery opened in November 2012. *Courtesy Mitten Brewing Co.*

Opposite, bottom: The interior at the Mitten Brewing Co. is located in Engine House No. 9, where the fire engines were once housed. *Courtesy Mitten Brewing Co.*

The historic Noble Building is where Pigeon Hill Brewing Co. is located in downtown Muskegon. The brewery opened in the summer of 2014. *Courtesy Michael Brower.*

Pigeon Hill Brewing Co. opened in 2014 to an excited Muskegon crowd. *Courtesy Michael Brower.*

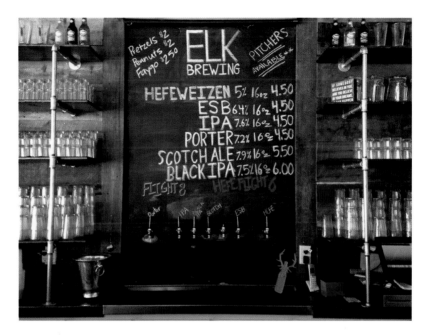

Elk Brewing keeps an industrial theme to its taproom, which took nearly three years to open. *Courtesy Elk Brewing Co.*

Quickly following White Flame Brewing Co.'s opening, it became a local watering hole for many Hudsonville residents. *Photo by Steph Harding.*

A beer from Pike 51 Brewing Co. is poured on a bus carrying brewers and Grand Rapids beer fanatics as they promote BeerCity, USA. *Photo by Steph Harding.*

Grand Rapids was named BeerCity, USA two times by an Examiner.com poll and helped invigorate the beer following in the city. *Photo by Steph Harding.*

In September 2014, Founders Brewing Co. announced a massive new expansion project. The project would more than double its footprint at the 235 Grandville Avenue location, adding thirty-seven thousand square feet of space. Included in the expansion was a three-hundred-barrel brewhouse, one of the largest systems in a craft brewery in the nation.

The new brewhouse, combined with all the old equipment, new fermenters and packing equipment, would allow Founders to eventually grow to more than 900,000 barrels annually. In 2014, the brewery was set to brew more than 200,000 barrels of beer and would likely grow to more than 300,000 by the end of 2015.

"The focus of this expansion is to increase the capacity of our production facility—to brew more beer right here in Grand Rapids, Michigan," Stevens said. "Because of increasing demand from the growing beer enthusiast community, we aren't able to fill orders right now. We're expanding because we're committed to this city, this state and the craft beer community."

CHAPTER 15

HOLLAND'S NEW BREWERY

Jason Spaulding and Brett VanderKamp first experienced the amazing world of beer on a Hope College soccer team trip to Europe. On the tour, the pair saw what beer meant to communities, and it sat in the back of their heads for several years as they finished their schooling.

Following college, VanderKamp moved to Colorado with the thought that a brewery could be started out west. But soon, the pair of best friends had realized the best option was their college town of Holland, Michigan.

The pair started with a four-thousand-square-foot brewery and taproom at 205 Fairbanks Avenue in 1997. New Holland Brewing Co. was fed by naiveté in the early days, according to Spaulding.

"When we started, we were just out of college, pretty young kids, not really understanding all it would take, it was just passion driven," he said. "We just wanted to do it. We just figured it out."

Spaulding and VanderKamp didn't have established roles in the early days, and both were doing a little bit of everything: running the pub, brewing the beer and keeping the operations going.

"We'd start at 8:00 a.m. brewing beer, and then we'd be in the pub 'til midnight," Spaulding said. "It was brutal, it was just a slugfest, trying to figure out what to do."

As the daily tasks revealed themselves, the roles were redefined. VanderKamp took the reins of the brewing operation, while Spaulding handled most of the finances and the pub.

Patrons cheers with fresh New Holland Brewing Co. beers at the original 205 Fairbanks Avenue location. *Courtesy New Holland Brewing Co.*

Brett VanderKamp brews an early batch of beer at New Holland Brewing Co. *Courtesy New Holland Brewing Co.*

A look into the New Holland Brewing Co. Eighth Street location prior to the company moving its taproom there in 2002. *Courtesy New Holland Brewing Co.*

Early in the craft beer scene, breweries were often hanging on with very little capital to work with and not a large market. Hardships from those early days bound the New Holland founders tighter, as they did what they had to do to survive. VanderKamp and Spaulding were each doing what they could to get the company to the next day with the lights on. Finances weren't always as good as they could have been, according to Spaulding, but the pair kept chugging as they continued to throw money into the growth of the brewery.

In 2002, the brewery moved into its new digs at 66 Eighth Street, an ideal corner location for the pub in the middle of downtown Holland. Production stayed at the Fairbanks location until a new production facility was constructed several years later.

As success began to come to the brewery, Spaulding and VanderKamp were able to step back and look at where the brewery was headed and where they each wanted it to go.

"Once we were more matured, eight to ten years into it, and you start to have time for planning," Spaulding said. "Once we became successful, that's what started to erode those things. It was the time to figure out where this brewery was going, and all of a sudden, one day it was obvious we were on a different plane, and it wasn't going to come together, and something needed to change."

For a while, things stayed the same as the brewery continued to grow. Eventually, the different views took their toll. With their views continuing to separate, Spaulding left New Holland Brewing Co. in 2005.

"It was really hard to let go of something that was a business that never should have stayed a business but we put all we had into it, nurtured it and kept the business alive based on pure passion and work and hours," he said. "It's hard not to have it be a part of who you are. It was hard to let go because I was proud of that, excited about that."

The next year, New Holland embarked on a major new endeavor: distilling. Meanwhile, the beer production had made its way to more than five thousand barrels of beer a year.

With a production bottleneck looming stemming from two years of more than 50 percent growth, New Holland embarked on construction of a significant twenty-two-thousand-square-foot production facility at 690 Commerce Court in Holland Township.

"We were hoping to stay within our current facility through [2006] and into the first quarter of '07," said New Holland president Brett VanderKamp. "But unfortunately, we couldn't handle it anymore. We didn't think we could get through one more peak season."

Brewery upgrades increased capacity from six thousand barrels at the original location to thirty thousand barrels and plenty of room to grow.

In 2008, New Holland Brewing Co. acquired an old German mash tun and boil kettle from the centuries-old Brauerei Bahr, which had recently closed in Bavaria. The 50-barrel brewhouse gave New Holland the potential to brew more than 10,000 barrels annually. The expansion was needed to meet a 40 percent growth trend the brewery had seen in 2007, growing from 7,600 barrels to 10,000.

The beautiful, aged copper system was installed at the brewery's production facility. Prior to the installation of the brewhouse, a 350-bottle-per-minute bottling line was installed.

Historical alcohol-making apparatuses seemed to hold a close spot to VanderKamp's heart, as he also purchased an eighty-year-old, eight-hundred-gallon still from a Prohibition-era farm in New Jersey, where it made applejack. He had purchased it in 2006 and put approximately $50,000 into the restoration of the still. Prior to the 1932 still operating, the distilling operation utilized a sixty-gallon still, which remains in use.

VanderKamp attempted to use his status as the owner of a growing microbrewery to run for political office, but he lost in the August 2010 state senate primary in the Thirtieth District.

"I'm glad I did it, but the experience I had with it as somebody who had started his own business and makes his own decisions—I'm not cut out for it," he told the *Grand Rapids Business Journal* in 2012.

New Holland offers a traditional first-wave approach of brewing with an eclectic portfolio of beers. Led by the Mad Hatter IPA series and a variety of entry level–type brews such as Sundog Amber Ale, Paleooza Michigan Pale Ale, the Poet Oatmeal Stout, Cabin Fever Brown Ale and Full Circle Kolsch, New Holland offers a solid lineup for West Michigan beer drinkers. Dragon's Milk bourbon-barrel imperial stout is one of the brewery's most popular beers and is one of the only barrel-aged stouts available year-round in the country. For its specialty brews, New Holland runs the gamut and brews a variety of barrel-aged brews, such as Blue Sunday sour. New Holland's Ichabod pumpkin ale is also immensely popular among beer fans.

The vast portfolio led to quick growth in the latter half of the 2000s and necessitated brewery production expansion. In 2012, New Holland spent $3 million to upgrade its production facility, which included five four-hundred-barrel fermenters that came from German company Ziemann and helped double production space.

"We couldn't push another drop of beer through the system right now," VanderKamp told the *Grand Rapids Press* in 2012. Approximately twenty-three thousand barrels were brewed in 2012, and the expansion upped capacity to fifty thousand barrels per year.

The expansion allowed the brewery to double its production of Dragon's Milk, which ages for ninety days in a cellar that can hold more than three thousand bourbon barrels full of the liquid. New Holland prides itself on the usage of barrels, which house Dragon's Milk twice and then head to the sour beer–producing "House of Funk" or the distillery. Following use in the distillery, they can go back to the bourbon barrel room and be used again. Eventually, the barrels go to the company's Barrel Works Project, which was started in 2013 and makes a variety of products from chairs to guitar stands out of used barrels.

The same year, New Holland released a Hatter Series of its standard IPA and varied the options available during the year, including a Black IPA, Rye Hatter and Oak-Aged Hatter. VanderKamp also made it known a location in Grand Rapids was being scouted, but the process had become strained and taken a lot longer than the team had initially planned.

The year 2013 ended up being a big one for New Holland as well. The brewery embarked on and opened a $1 million renovation of its back patio,

including an outdoor bar, band booth and seating for more than seventy with a canopy covering half the outdoor space. With added space, the kitchen also needed upgrading.

A change in the brewery's identity came in January 2014 as New Holland embraced the art of beer. Following the motto "Stop and Taste," New Holland helped change the branding on six-packs to stick out on shelves and used keywords, such as "citrus," "aromatic" and "balanced," to help pinpoint what drinkers might seek out of a beer.

"We're trying to talk to consumers in flavors, making a connection," New Holland's manager of community relations Emily Haines said at the time. "We want to key people in to what to expect. We respect people's tastes, and if our beer isn't what they're into, we want to be honest with them."

Design changes kept elements of the brewery fans had become familiar with, such as dragons, ravens and the hatter characters.

Later in the year, a collaboration with Dearborn-based Carhartt was announced for the workwear brand's 125th anniversary. A barrel-aged pale ale, the Carhartt Woodsman, was released later in the year with the Road Home to Craftmanship tour.

The tour took a thirty-four-foot 1947 Spartan trailer, outfitted for beer serving, from Carhartt's Dearborn headquarters to Denver for the Great American Beer Festival, stopping along the way to hear the stories of workers across the country.

Generally taking a back seat in West Michigan to Founders, New Holland could stand alone in many other regions. Beers from the brewery fare well in competitions, including Pilgrim's Dole, a wheat wine that won the National Grand Champion award at the United States Beer Tasting Championship three years in a row. Sitting at 11.8 percent alcohol, Pilgrim's Dole also won a bronze medal at the World Beer Cup and a gold medal at the Great American Beer Fest.

The spirits side of the company also wins medals. Knickerbocker Gin, Walleye Rye, Zeppelin Bend Single Malt Whiskey and Beer Barrel Bourbon have all won medals at national competitions.

In October 2014, following years of searching, New Holland decided on and announced a Grand Rapids location. The project will take up $10 million of a $17 million mixed-use project on Bridge Street on the west side of the city. New Holland will bring its sour beer production, single malt whiskey and a taproom to the facility when it opens in late 2015 or early 2016. Brewing will be done on a twenty-barrel brew system with several forty-barrel fermenters and a traditional Belgian horizontal open-top fermenter

called a cool ship. Fermentation in a cool ship is all natural, allowing yeast and bacteria to settle into cooling wort. The cool ship can also be used for sour mashing single malt whiskey. Production at the facility would only ever equal a few thousand barrels, VanderKamp said.

CHAPTER 16
EUROPEAN INSPIRATION

Following Jason Spaulding's departure from New Holland Brewing Co., he was crushed and still tied to the brewery through various ways. It was hard to go from putting so much into a company you helped build to looking for a job.

"I still had some ownership in New Holland when I left," Spaulding said. "I had all these little fingers weaved into that company because of the way we started. I was struggling because I didn't know if I stay on the outside as a board of directors sort of thing. But that wasn't going to work, because I wanted to be in it."

Spaulding went to work at Lakeshore Advantage, a business consulting firm. Making a decent wage in the nine-to-five world, however, wasn't enough to keep Spaulding happy. His wife, Kris, came to know the two years following the New Holland departure as the dark years. She was sick of how the only topic of conversation that would bring Spaulding out of his state of funk was opening a new brewery. During those years, he was also asking himself the tough business questions, like, "Does the world need another brewery?"

Eventually, Kris had had enough, and instead of putting up with it, she told him, "You gotta stop talking about this. If you're going to wonder what could have been, you need to make a change and just do it."

So after his wife's kick in the behind, Spaulding quit the consulting job and went to the Doemens Academy in Munich, Germany, for a course in brewing, a condensed version of Siebel Institute's master brewer program.

"I knew enough of what I needed to know," he said. "I wanted to dive a little deeper in microbiology. That just reinvigorated stuff. It'd be great to take a brewmasters course, but I didn't have the two years to do that or move to Chicago. But it was a really invigorating thing, and it's what I needed."

Following the course, Kris met Jason in Europe, and the Spauldings went on a tour of France and Belgium. Prior to the trip to Europe, the Spauldings loosely had the theme of their future brewery based on the Belgian-inspired beers, but the trip ensured that's where their lives were headed.

"That's what cemented it, when we met the brewers and drank the beer," Spaulding said. "We always kid around; my wife loves Champagne and we were in the Champagne region of France, but we didn't drink any because we were always drinking beer. We were that excited about the breweries."

Upon his arrival back in the States, Spaulding wound up working at Zingerman's Roadhouse, a restaurant under the Zingerman empire in Ann Arbor. Each entity under the Zingerman name is somewhat independently owned under the company's overall branding. Spaulding had chatted with the company to open his Belgian-inspired brewery under the Zingerman name in Ann Arbor.

"I thought if I'm going to do these styles, it's too risky in the market to really do it, but if I had the Zingerman's name behind it, I could concentrate on that sliver," Spaulding said.

He worked for a year, helping manage the Roadhouse while commuting back and forth to Holland, staying in Ann Arbor four days a week, while Kris kept her job at furniture manufacturer Herman Miller. By the end of the year, he was ready to roll on the brewery idea, and he had a meeting with the Zingerman owners. They liked the idea but weren't ready to proceed for another two to three years.

"These guys weren't beer people, [so] it was going to be a slow process," he said. "I'm like holy shit, I'm barely containing myself. That's when we decided to come back to West Michigan and do it."

Spaulding said he learned a lot in the year he was with Zingerman's, which has a well-respected reputation behind it. In his new company, he

Opposite, top: The stables at the Metcalf Funeral Home, where the brewhouse at Brewery Vivant is now located. *Courtesy Brewery Vivant.*

Opposite, bottom: The chapel at the Metcalf Funeral Home, where the bar at Brewery Vivant is now located. *Courtesy Brewery Vivant.*

knew he would end up basing a lot of the operation on the way it ran. All the time away from New Holland and the brewing industry helped further solidify what Spaulding did and didn't want to do.

Still, it took some time for Spaulding to find the right location for the brewery, trying to decide whether it'd be in Traverse City, Holland, Ann Arbor or several other sites. But upon entering an old funeral chapel in the East Hills district of Grand Rapids, he found its home. As soon as he walked into the chapel, he knew the feel was exactly what he was looking for.

"It already looks like a monastery, it just has to happen here," he said were the first words out of their mouths when he and his wife were looking at the building.

He asked his old fraternity brothers Mike Stevens and Dave Engbers if it'd be OK if he settled into a spot in Grand Rapids. They were happy to say yes, as another experienced beer maker would only help the craft beer market grow.

The location cost a little bit more than he wanted, but everything came together despite possibly the worst financing climate in nearly one hundred years.

"Beginning the second brewery, I was more knowledgeable, more mature," he said. "But it was still brutal. Then I was just set on proving that people were ready for these beers and this setting in this neighborhood."

Brewery Vivant opened its heavy wooden doors on December 20, 2010. It was a soft opening, with just three types of beer. No food was offered in the opening, but before long, the menu was a main focus at Brewery Vivant. Beers and food are often designed to go with each other, a task Belgian beers are well matched for, as their complexities can rival those of wine.

Brewer Jacob Derylo had been in chats with Spaulding since before the brewery had been announced but had to keep it quiet as he was still a brewer at New Holland when planning was ongoing. Derylo was happy to join an operation that focused on beers he had loved since he started homebrewing in the 1990s.

In the first year following its opening, Brewery Vivant was named to *Draft Magazine*'s Twelve Breweries to Watch in 2011 and *Midwest Living*'s Top 25 New Places to Stay, Eat and Play. In 2014, *Esquire* added the brewery to a list of the fourteen weirdest brewery locations in America.

Spaulding kept the brewery true to the European model: small and community oriented. He said the brewpub is at the heart of the operation and always will be, with limited distribution throughout the state and Chicago and possibly one other market.

Brewery Vivant's French- and Belgian-inspired beers were the result of a long planning process for owners Jason and Kris Spaulding. *Photo by Damon Card.*

A Brewery Vivant wood-paddle tap handle, with its rooster logo, is easily visible in bars across the state of Michigan. *Photo by Bryan Esler.*

"We have all our passion in this place," he said, adding that it wouldn't be the same if he opened up several more brewpubs because it would lose the charm. "We want to concentrate on being a great company rather than a big company."

Beer will always be at the heart of Brewery Vivant, but the focus is also on the community. Kris Spaulding is at the forefront of the company's sustainability movement. When the taproom opened, it was certified LEED Silver, the second level of the sustainability accreditation. In 2014, Brewery Vivant was also named a B Corporation, which recognizes companies that meet rigorous guidelines of sustainable business practices.

From the start, the pair had goals for their business:

- 90 percent of all purchases made within 250 miles
- 75 percent of all purchases made from Michigan businesses
- 50 percent of food inputs from 250 miles
- 25 percent of beer inputs from 250 miles
- 10 percent of profits to charities
- 25 percent of donations go to East Hills neighborhood
- 10 percent of profits to employees through profit-sharing
- 200 employee volunteer hours
- Zero waste to landfill
- Water to beer ratio 3:1
- 10 percent of food grown at the Vivant farm
- Annual reduction of carbon footprint/sales

An annual report called *Beer the Change* reviews the goals on a yearly basis and cites the improvements made from the previous year.

Brewery Vivant runs an open-book company, also offering employee shares in the company, healthcare and a variety of other benefits. All employees also go through a couple classes when they're hired to develop a better understanding of the company.

"It's a chance Kris and I can [use to] get to know the employees," Spaulding said. "It's a little conversation, but we teach people the same information."

When it was not even two years old, Brewery Vivant was a collaboration partner with New Belgium Brewing Company, the nation's third-largest craft brewery in Fort Collins, Colorado. Together, they made a Belgian amber aged with Brettanomyces, a bacteria that helps create sour beers. Brewery Vivant hosted a dinner on a farm on the outskirts of Grand Rapids with New Belgium, a beautiful twelve-course pairing meal with both of the breweries' beers. Vivant made 180 barrels of the beer on its end, and it was the first American beer brewed with wild yeast to be

canned. It was named Escoffier, after the acclaimed French chef Georges Auguste Escoffier.

The launch of Escoffier helped introduce New Belgium to the Michigan market, and the collaboration started as a brief stop in the taproom as New Belgium was setting up accounts in Grand Rapids.

"Somewhere along the line we started talking about doing a collaboration beer together to coincide with their debut in Michigan," Spaulding told *MLive* in 2012. "That sounded like a great idea to us."

New Belgium Brewing Company's portion of the beer was released as part of the popular Lips of Faith series in twenty-two-ounce bombers. The beer helped put Brewery Vivant's name in front of much of the country, as New Belgium is distributed across nearly the entire nation.

Brewery Vivant has put a cap of five thousand barrels annually to help maintain the community feel of the brewery. The brewery is a hub of activity, regularly hosting events such as a collaboration seafood dinner with the Downtown Market's FishLads and an annual Wood-Aged Beer Festival, which grew until it closed Cherry Street. Employees from the brewery also regularly volunteer at various nonprofits in town and at the neighborhood school across the street.

"Our effort will go into how to do things better, how do we make this better for employees, more profitable, the more we can share and be a part of the community," Spaulding said. "I like the community feel, the relationship with the customers. I never really liked the wide distribution model with dozens of states. I like more of the personal connection and being in the community and in the neighborhood and keeping the creative aspect of the beer."

CHAPTER 17

SELLERS MARKET

GRBC REINCARNATION

In 1992, the Michigan legislature pushed through a bill allowing brewpubs and microbrewers in Michigan. The bill was simple, but it was a huge step for an industry waiting for the cue to grow. Prior to the bill, brewing operations were classified as "Brewer" and could not sell beer or food on premise. With the bill in 1992, brewers could now be classified as microbreweries or brewpubs and were allowed to sell beer and food on premise.

This came shortly following Michigan's all-time low of three brewery licenses: Detroit's Stroh's, Frankenmuth Brewing Company and Kalamazoo Brewing Company.

Kalamazoo Brewing Company, which eventually turned into Bell's Brewery, was the first to serve beer on location, but before long, brewpubs began to pop up across Michigan. Grand Rapids Brewing Company on 28th Street was the second brewpub in the state and, before long, was the longest continuously operating in Michigan. In July 2010, Schelde Enterprises sold the company to partners John Ljuljduraj and Mark DeHahn.

Under the new management, the 28th Street Grand Rapids Brewing Company allowed its lease to expire and closed in 2011, lasting nearly twenty years in the outskirt location. Following the closure, new Grand Rapids beer baron Mark Sellers purchased the assets of the brewery with the intention

of moving the brewery back downtown. Sellers said he would have bought it when Schelde Enterprises sold it the first time, but he had no idea it was on the market.

"I didn't hear about it until after it was done, and I remember regretting it because the brand is great but the beer isn't and the location isn't. They went straight down hill, they didn't bring it downtown where it belongs, and I got my chance," Sellers said in an interview in the fall of 2012. "I thought for a few years before I bought it that if it ever becomes available I'd love to buy it. As soon as I read in the newspaper that they would shut it down in a few days, I immediately did what I could to buy it from the landlord from the mall, because they owed so much back rent."

The new Grand Rapids Brewing Company landed on the corner of Ionia Avenue and Fulton Street, one of the premier corners in downtown and just doors down from Sellers's massively successful beer bar HopCat. The location is situated next to Van Andel Arena and serves as the entrance to the downtown entertainment district.

Before finding the home on Ionia Avenue, Sellers had attempted to land in the Brass Works Building, the original home of Founders Brewing Co., before the deal stalled, leaving the reopening of Grand Rapids Brewing Company downtown in the air.

Leading up to the opening, reports had been published that Sellers was unsure whether to go with a microbrewer or brewpub license. In the end, he ended up going with the brewpub, which doesn't allow for outside distribution and permits service of outside beer, wines and liquors. Prior to his purchase of the Grand Rapids Brewing Company rights, plans had been made by Sellers to open Beatnik Brewing, which would have been a two-story brewpub and bowling alley at 62 Commerce. The bowling alley would have been miniature.

"There are 43 brewpubs in Portland, Ore., and in Grand Rapids, there are about five, and Grand Rapids is more than half the size of Portland," Sellers told the *Grand Rapids Press* in 2010. "Plus, in Grand Rapids there is not a restaurant-brewpub except for Grand Rapids Brewing Company, and that serves a different market."

Since his decision to keep Grand Rapids Brewing Company a brewpub, he's hinted that he's surprised that many of the other breweries opening in West Michigan are attempting a go at being microbreweries instead. He said beer store shelf space is extremely crowded at this point, but with more than one thousand restaurants, many more could implement their own house brewery.

"In terms of breweries that distribute their beer, I think anyone trying to start one now is crazy. I don't think anyone should do it. I think the only way to make money is selling good food. There's no shelf space," he said.

Sellers funded the project with a mixture of bank and personal financing, upward of $1.5 million, as part of a larger $7.5 million apartment complex that rests on top of the brewpub.

The downtown location showcases the old brewing equipment on the main level, brewing roughly 2,500 barrels of beer per year, including the continuation of Silver Foam. The recipe, however, differs from the pre-Prohibition lager that made the brewery famous across the Midwest. A transfer of a pre-Prohibition GRBC logo on an advertisement now serves as the brewery's new logo.

Despite reopening when there were more than one hundred breweries in Michigan, Grand Rapids Brewing Company was able to carve its own niche: organic. Now, organic ingredients are hard to come by and must be sought out, but when the original Grand Rapids Brewing Company opened at the end of the nineteenth century, everything was organic, Sellers said, explaining that this was a way to stay true to the brewery. Before the brewpub opened on December 5, 2012, the operation was already USDA-certified organic.

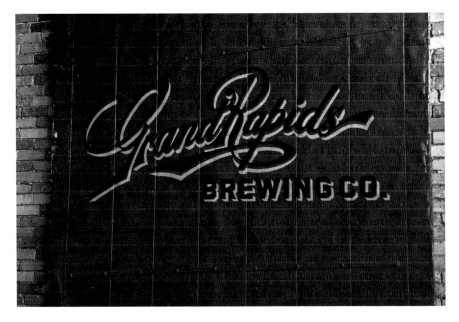

Grand Rapids Brewing Company's logo, seen here on a door inside the brewery, was traced from a pre-Prohibition ad of the original brewery. *Courtesy BarFly Ventures.*

Like many breweries opening in the time after 2011, Grand Rapids Brewing Company had trouble keeping its beer on tap. Despite pushing the grand opening off more than a month to brew up what management had thought would be enough beer, the brewpub was quickly drained of its supply. Less than ten days after its opening, Grand Rapids Brewing Company posted a notice from Sellers, explaining the purchase of three new fifteen-barrel fermenters and the decision to employ sixteen guest taps, along with just two house taps.

The bar employs massive amounts of wood and retro artwork to harken back to the days when Silver Foam flowed freely in the Midwest. The floor is made from reclaimed wood from the inside of the building, and the brick walls are original to the building that is more than a century old.

Rustic looks are completed by two bars inside that serve up the brews and a wide selection of liquors and food, specializing in farm-to-table food, including hand-cranked sausages and poutine with duck gravy and cheese curds.

Beers run the gamut from light lager to stout and are named after a variety of famous Grand Rapids landmarks and politicians past and present, such as Rosalynn Bliss Blonde, John Ball Brown, the Fishladder, Senator Lyons Stout and Ominous Rapids. The names are a way to help the brewery keep with a historic theme, Sellers said.

"There isn't a whole lot that is consistent with the original brewing company," he said. "It's a really old building, but it's essentially all new. New, but feels old. That's how I want my places to feel, like they've been around a long time."

The beer has been lauded by some, even garnering awards at prestigious competitions. One of the most heralded GRBC beers is the Log Jammer Maibock, which scored a gold medal at the World Beer Championships and was one of the top eight Maibocks ever tested at the event, including the only one certified organic.

The historical political naming earned its wings when the brewery's Distinguished Eagle barrel-aged imperial stout took home a silver medal from the World Beer Cup in 2014. The beer was named after Grand Rapids' own Gerald R. Ford, who was an Eagle Scout.

Although it is a brewpub, Grand Rapids Brewing Company does allow for growler fills and offers occasional bottle releases. Its first such release was on June 1, 2013, with Polish Eagle, an imperial porter. Distinguished Eagle and a series of Belgian sours also highlight the list of beers that have been incorporated in taproom bottle releases.

Aside from award-winning beers, the brewery also has established itself as a prime brunch location in the downtown area, offering a succulent menu and a large Bloody Mary bar.

Since opening, the bar has done its job as the entrance of Ionia Avenue, but Sellers seemed less than overjoyed at the first year and a half of operation. He said, "Things are pretty good. It doesn't do as well as HopCat, [but] it does well enough that I can say it's been a success."

THE BEER BAR THAT STARTED IT ALL

By the time Sellers opened Grand Rapids Brewing Company, he was a seasoned beer bar professional. That wasn't the case when he came back to Grand Rapids from his hedge fund management days in Chicago.

To understand Sellers would be a lifelong endeavor. He was born in Kalamazoo, Michigan, before moving with his family to Grand Rapids, where he stayed until he was eighteen.

He then went on to Michigan State, where he spent some time before dropping out. He ventured into the music world, first teaching himself to play piano and finding his way into Berklee College of Music in Boston. That didn't last long as he made the move to Los Angeles, where a rock career was born. But a life as a keyboardist and guitarist wasn't for him, either.

A reading binge of Ayn Rand and Warren Buffett led the twenty-six-year-old Sellers back to Michigan State, where he reenrolled and graduated with a degree in accounting. He moved to Chicago, spent time with a few investment firms and earned his MBA at Northwestern University before starting up his own hedge fund, Sellers Capital.

Before long, Sellers was managing a $300 million portfolio. Then the financial crisis of 2008 hit, and Sellers lost money—a lot of money. That year, he sold all of his funds' stocks and returned money to investors—all of the stocks except for one, the stock that holds the salvage rights to the *Titanic*, Premier Exhibitions.

With his pseudo-retirement, Sellers needed something to keep him busy.

"I was gone about twenty years, and Grand Rapids had changed a lot since I left. Grand Rapids got more interesting because of Van Andel Arena, and I became a beer fanatic when I was away," Sellers said. "I wanted to slow down my pace of life."

The same time he moved back to Grand Rapids, a local restaurant called the Sierra Room announced it was closing. Sellers loved the location, right next to the arena. So he told his wife at the time, Michelle, that he wanted to open a bar in the great location. He wasn't looking to make a living or create the next restaurant group of Grand Rapids. Sellers just wanted a place to hang out with the beer and food he likes. HopCat was his new hobby when it opened in January 2008.

The building lent itself to one of Sellers's first criteria: comfort. He likes old buildings, and the 125-year-old building in which HopCat is situated is warm with character. There's exposed brick, wood floors and iron poles throughout the brewpub. The dark brown wood bar runs the length of the L-shaped room. Sellers capped off the theme of the room by placing big brass tap towers on the front of the bar.

"We spent a lot more money on those than we needed to, [but] it just cements the notion that beer is the focus of this place," Sellers said. "You see all those big tap handles right on the front of the bar."

Still young, HopCat feels as though it's been there for many years. Sellers likes it that way, as he enjoys bars with a sense of history to them. HopCat's history is rapidly writing itself, as it continues to rack up notoriety and awards.

When it was a tad over a year old, *BeerAdvocate*, one of the nation's leading beer publishers, discovered the beer bar and rated it the number three beer bar in the world. That ranking was the start, as the accolades continue to roll in. *Draft Magazine* regularly ranks it in its top fifty bars in the United States, CraftBeer. com rates it as the number two beer bar in the United States and RateBeer.com has ranked HopCat as the number one brewpub in the United States.

Although he didn't set out to make money with the bar, Sellers had always hoped to make it on those lists. He had been to many of the bars that continually landed on those top fifty lists, and he liked his chances.

"I told the staff [on] opening day, this is going to be one of the top fifty beer bars in the world," he said.

The way to the top of the world's beer bars seems like an easy path, if one looks at the route HopCat took. But it was a well-designed program. Many bars have more taps than HopCat, but it's how the bar stocks those taps that helps separate it.

"The Grand Rapids location proves that it's not how many taps you have, it's what you do with those taps," Sellers said in spring 2014. "So long as you have a certain number, forty-five or so, then you have enough of a palette to work with."

Now, it helps that the bar has developed and maintained a world-renowned reputation. But earning that reputation wasn't easy. HopCat at that time had

a secret weapon, Steve Smith, who played the role of "chief beer geek." His sole responsibility was the development of the bar's beer menu.

"When we opened, we made a huge focus to push and develop relationships with suppliers who distribute rare beers," Sellers said, crediting Smith with the respect level near the beginning.

Smith eventually moved on, but HopCat maintains a person on staff who works with breweries and distributors to ensure HopCat continues to bring in rare and sought-after brews. Beer menus are reprinted at least three times a week because the beers are rotated so frequently.

"The secret to success in the beer world is the fact we don't care if we can only get a sixth barrel of something for one day," Sellers said. "We'll still put it on. We don't require breweries to send us enough that we can keep a beer on a long time. That's what makes it fun for us, to rotate as much as possible and that is sort of what differentiates us from a lot of other beer bars."

The bar doesn't have a macro selection—save for a "lawnmower" tap, usually PBR or Rolling Rock—and it often strays from commonly known examples of styles. Sellers said HopCat likes to delve deep into the beer styles and offer an assortment of lesser-known breweries or lesser-known offerings from large breweries.

Sellers said there's another reason a bar couldn't set up shop across the street with forty-eight taps and replicate the success of the original HopCat: the servers. Staff at the brewpub is Beer Server Certified by the Cicerone program within ninety days of being hired. Some other bars require that certification as well, so HopCat has moved on to a continuing education of classes taught in house and constant beer training. Sellers said at the start, the company just hired beer geeks, but now it's an "intense, formal program."

Food helps too, and Sellers didn't want to intimidate any customer with the menu. Its quintessential item is Crack Fries, a basic French fry with a special spice blend.

"It's all stuff that I liked; it was all for me," Sellers said. "I don't want to say I have an average taste in food, but I like good burgers. I like to think I'm a little more discerning, so it's upscale bar food."

The first year, HopCat blew Sellers's expectations out of the water, bringing in about $1.8 million in revenue. Six years into the operation, it brings in more than $4 million. Sellers said he wasn't afraid of failing when he opened, but only because he didn't realize how hard the beer business is to succeed in.

"I was naïve; I just assumed if I created a great bar that was fun to hang out in, it would at least break even—that's all I really cared about," he said.

"It ended up doing much better, and I've made a second career out of it and [am] making pretty good money out of it. But that's not why I did it."

Initially, Sellers said he had no intentions of taking HopCat beyond Grand Rapids. Still, his company, BarFly Ventures, began operating several other operations. Stella's Lounge is a retro bar with the most extensive whiskey list in Grand Rapids. For a period, Stella's also included the Viceroy, a Prohibition-style speakeasy that required a password to get in. The company also helped get music venue and pinball haven the Pyramid Scheme off the ground, and it took over management and eventually ownership of McFadden's Irish Saloon.

Stella's and Viceroy both opened in 2010, with Viceroy closing in 2012 as business didn't equate to what was hoped. Stella's took over the space as an expansion and has taken off since *GQ* named the bar's burger the "Best in America."

But with the success came more ideas for Sellers. In fall 2012, he announced that his brewpub and HopCat schemes would head to East Lansing, home to Michigan State University, his alma mater. Both Lansing Brewing Company and HopCat East Lansing were slated for opening in summer 2013.

"People who live in Lansing might not know what they're missing," Sellers said at the time. "I just know there is a pent-up demand."

Lansing Brewing Company ended up falling through because of lease issues, but HopCat East Lansing did open up in August 2013 with a one-hundred-tap takeover with Shorts Brewing Co. At the time, one hundred taps was the largest selection in Michigan, and Sellers took the same approach to filling the selections.

Early in 2014, Sellers announced a massive expansion of HopCat, starting with a $3.3 million location in Detroit, including a live music venue and beer garden. A few weeks later, he announced the expansion into other states, beginning with Indianapolis, and eventually up to fifteen other college towns and cities such as Milwaukee, Columbus and Chicago. The Indianapolis location opened in August 2014 with a 130-tap takeover with all Indiana craft beers.

He initially hadn't planned on making the HopCat name a chain, but the success continues, as East Lansing is the highest-grossing operation. The bars might reach across the Midwest, but Sellers said the Grand Rapids location always will be the original—and the only brewpub—and each location will have its own unique design incorporated into buildings that all have their own characteristics. One thing is for sure, he said: they'll all have the same beer programs, focusing on the region's local brews.

"For five years, that was true," Sellers said of Grand Rapids being the only location. "Then the opportunity in East Lansing came up. I couldn't pass it up. Then we dipped our toe in the water, and it's gone even better than the Grand Rapids one, and I decided to do a bunch more and see how it goes."

Sellers has helped Grand Rapids stake its claim as one of the best beer cities in America, and he's putting one of the city's premier beer brands in cities across the country. Many of the ideas he has touched have been a success. He's had his failures—the Viceroy, Beatnik Brewing Company and Lansing Brewing Company—but those have been balanced by even larger successes.

"When you do something you love, things usually work out—except when they don't," Sellers told the *Detroit Free Press* in 2012.

Chapter 18

A Second Wave

2600 Patterson

Shortly following the closure of Robert Thomas Brewing Company, the building, brewhouse and even the regulars found a new brewer.

Jim Schwerin met his future wife, Laurie, when he was at Northern Michigan University and friends had a pipe dream of owning a brewery. That dream came a lot closer when Jim began brewing in Germany while in Europe for his work. Eventually, the Schwerins settled in southeast Michigan, where Jim continued to homebrew.

Friends continued to push Jim's confidence higher—high enough to start a brewery. The closing of Robert Thomas gave the Schwerins a turnkey operation that could be turned back into a production brewery without too much investment in late summer 2004.

With a fresh coat of paint, a revamped bar and quick work by the state's bureaucrats, Schmohz Brewing Co. opened on December 17, 2004. Four beers were on tap opening night: Valley City Cream Ale, Mad Tom's Robust Porter, Gypsy's Kiss Bock and Amber Tease, a California common ale. Later, Bonecrusher Stout and an English IPA were added to the regular lineup. Other beers came as well, such as Miracle Off 28th Street, alluding to the quick liquor license transfer that first December; Kiss My Scottish Arse; and Hopknocker Imperial IPA.

Schmohz brewed 350 barrels in 2005, the first full year of production and a year before both Founders and New Holland embarked on significant expansion projects.

"The breweries here have grown out of their capacity," Schwerin told the *Grand Rapids Business Journal* in 2006. "They're building larger facilities, and that's good for everyone. I expect my growth to come pretty quickly based on what everyone else is doing."

Retaining the same system as Robert Thomas—a twenty-barrel brewhouse, three sixty-barrel fermenters and a twenty-barrel fermenter—Schmohz had an initial capacity of eight thousand annual barrels. A bottling machine also was inherited and helps the brewery distribute statewide with both draft and retail accounts.

In another nod to the days of Robert Thomas, the brewery continues to make and distribute soda, including a popular root beer and a cherry soda.

In 2013, Schmohz Brewing Co. brewed 1,600 barrels with brewers Chas Thompson and Gabi Palmer. Thompson has quickly asserted himself as one of the quirkiest and most well-known brewers in the Michigan brewing scene.

With Grand Rapids' rapid rise to beer industry awareness, Thompson also has taken a role as one of the lead promoters to help rally the city's population around the craft beer movement.

Just as other breweries in Grand Rapids are committed to the community, so, too, is Schmohz. Every year, the brewery hosts the Achilles Ale 5K, a race that benefits the Special Olympics.

Schmohz does its best to foster a growing audience in Beer City by regularly hosting a ladies' night to help promote craft beer as more than just a boys' club and Michigan Tech alumni meetings, as nearly all the company's employees are graduates of the Houghton, Michigan school.

NEIGHBORHOOD HARMONY

The three siblings running Bear Manor Properties had had enough of being landlords, setting up awesome businesses and watching them host great times without any say in the businesses. Following a quick succession of setting up a stretch of businesses on Wealthy Street—the Meanwhile, Electric Cheetah and Brick Road Pizza—Heather Van Dyke–Titus and her two brothers, Barry and Jackson Van Dyke, decided they needed to do something on their own.

The situation was helped by the fact that the real estate market was in decline and their hands were forced. The trio was able to purchase Jack's Liquor store at 1551 Lake Drive Southeast, a storefront that had spent more than a decade as an empty eyesore.

Barry and Jackson had homebrewed for several years, and the brewing industry was heating up, so it seemed like a no brainer. Combine the location that had been a sore spot in the neighborhood with the Van Dykes' passion for working with the neighborhood associations to make the city a better place, and it was a match made in heaven. Harmony Brewing Company opened on February 1, 2012, to a supportive East Grand Rapids and Eastown community and has since become one of the leaders in the Grand Rapids brewing industry, engaged in all things in the city.

More than $350,000 was spent on the project, and Jackson and Barry did roughly 90 percent of the construction work. Once the work was done, a dairy tank system was purchased for $20,000 from a dealer in Wisconsin, who drove it to Michigan on the SS *Badger* ferry across Lake Michigan. The dealer returned to Wisconsin with a truck full of blueberries. The repurposed system brews five barrels at a time, and Harmony quickly maxed out its capacity, brewing beers the brothers liked to drink and seasonals that utilize ingredients fresh to Michigan's seasons.

Many times, the decision of whether to be a full-service brewpub or distribution-capable microbrewery is a tough one, but Harmony's decision was easy. Since Bear Manor Properties owns locations that have liquor licenses, it couldn't receive a brewer's license.

Early in the brewpub's existence, it hosted an event called Black Squirrel University, a series of educational seminars in the space. That series has since been discontinued, but other events pull people in from all over the state. Ben Darcie hosts his annual Grand Rapids Beer Tasting Class at Harmony, and a local chapter of Pub Theology and Pints and Poetry all make Harmony a unique draw for the community.

"It's nice that people can identify with the brewery and the cool things that can happen when people implement their ideas," Jackson Van Dyke said. "It's just nice to see people claim ownership."

In late 2013, news started to leak that Harmony would make an expansion leap across town, charged by the lack of expansion room at the Lake Drive property. The second location is on the west side of Grand Rapids, near the home of many pre-Prohibition breweries, at 401 Stocking Avenue. It's a two-part building, part of which was built in 1908.

The other part was built more than a century later as the tenant, Little Mexico, rebuilt following a devastating fire. The inside is expansive and painted with artwork previous owners did while drugged up, Jackson Van Dyke said. They're keeping the trippy artwork but removing the Mexican cuisine–related paintings.

"It was a group of hippies who would sit around and do as many drugs as possible to decorate the room," Jackson Van Dyke said. "When it's done it's going to look like a beer hall."

Harmony Hall will open sometime in early 2015 and will help supplement Harmony Brewing with its capacity. To ensure the new facility would be able to fill both venues' needs, the owners took a trip to China to inspect the ten-barrel brewing system they bought for the location. With the system, they'll use twenty-barrel fermenters to turn out batches, hoping they didn't overestimate their production needs, Jackson Van Dyke said.

Altogether, the new pub will be capitalized with about $1.5 million, Jackson Van Dyke said, while knocking on the bar. But it'll be worth it.

"There are too many great things that have come from opening the brewery," he said. "It's great to be able to create something people appreciate. To open on that first day and see the excitement was great. And to be a part of the Eastown community and greater Grand Rapids brewing community, both are amazing."

BIG TIME

Randy Perrin doesn't like to do things small. Following years of building a successful clothing business at Perrin Sportswear, Perrin decided to make a move into a growing West Michigan industry. The company was churning at about $50 million in annual sales when he decided to embark on a brewing project, Perrin Brewing Company, so he set out to do it right.

Perrin brought on partner Jarred Sper, a former marine, Secret Service agent, model and New York event planner, to help run the company. When the pair announced the microbrewery, it was originally planned to be twelve thousand square feet. That was quickly amped up to twenty-three thousand square feet as Perrin constructed a new building right down the street from his clothing company in Comstock Park.

The exterior of Perrin Brewing Company in Comstock Park, which opened in September 2012. *Courtesy Brewstravelers.*

Outfitted in the new space was a long line of windows lining the wall of the taproom so customers could watch the entire process of brewery operations. The first year, that process brewed approximately three thousand barrels as the company started distributing a black lager and pale ale into West Michigan before the brewery opened in September 2012.

Brewing operations can scale up to twenty thousand barrels annually in the facility. Initially, the facility also contained a bottling line and an old church key canning line, but both were sold off within the first two years of operation. Had the canning line become operational, the brewery would have been the second to package beer in flat-top cans.

Perrin always prided himself on being an average guy and never let the money get to his head. He wasn't a big craft beer drinker and helps explain why Perrin Brewing Company caters to every possible taste bud.

"There's no reason we can't do both [craft beer and mass-market beer]," Perrin said in a rare interview with the *Grand Rapids Press* in 2012. "Why can't we bring the two together? I think it's a smart philosophy."

Included in the philosophy was the company's decision to stay away from crazy beer names. So, for the most part, Perrin's beer names go along with the style.

To make innovative beers that would hang alongside some of the other beers made in Grand Rapids, Perrin brought in several brewers with strong backgrounds. First was Thomas Nicely, who had come to Grand Rapids following time with Lagunitas and Goose Island brewing companies. Following Nicely was former Founders Brewing Co. head brewer Nate Walser, who spent five years on Monroe Avenue and helped develop the famed Kentucky Breakfast Stout.

Walser left the operation in the spring of 2013, at about the same time Perrin put package distribution on indefinite hiatus. With Walser's departure, Sam Sherwood was promoted to brewer, and John Stewart from Saugatuck Brewing Co. was hired on as well. Before long, Stewart was the brewery's main man.

The high quality of head brewers from the start helps explain why Perrin was willing to throw so much money at the operation.

"The more we started to work on it, delve into it and bring on very qualified brewers, it wasn't a deliberate choice right away," Sper said of starting so large. "It just happened organically. It happened that way because we had seen all the breweries around growing at such an exponential rate and it took them so much time, effort and resources to rip down and expand.

"So instead of playing that catch-up game, if we're bringing on world-class brewers and we really believe in our product, then why don't we do our best to enable them to make a good amount of beer for the pub and distribution?"

With a big brewery and beautiful taproom in tow, Perrin and Sper set out to make Perrin Brewing Company a destination and have done so, attracting workers from both the farms and factories near the brewery and businessmen from downtown Grand Rapids. Perrin Brewing Company has a dedicated following, and they all gather together on the brewery's anniversary in September for the Backyard Bash, a celebration with food,

music and beer. Although the brewery doesn't package for retail, it does bottle occasional twenty-two-ounce bombers of specialty brews. In its first full year of production, Perrin brewed roughly eight thousand barrels of beer and showed no signs of slowing down. The production was slated to hit between twelve thousand and fourteen thousand barrels in 2014, with the first bottles hitting retail shelves late in the year.

"Beer is like music; it's all encompassing," Sper said. "If we can continue to focus on that and make good beer, people will continue to come, no matter what."

HOME FOR TIGERS

Friends since first grade, Max Trierweiler and Chris Andrus had started homebrewing as a hobby. Soon, they took a serious approach to the hobby, learning every in and out of the science they could.

The pair started planning the Mitten Brewing Co. in 2009, well before the second wave of breweries started to open, when Treirweiler was a marketing professional at Trivalent Group and Andrus was a musician. When the pair were ready to move with their business plan, they walked through several buildings but always had their eyes set on a historic 1891 firehouse at 527 Leonard Street. Andrus and Trierweiler spent more than a year renovating the former engine stalls into the taproom and the horse stable into the brewery, tearing everything back to the original brick walls and open ceiling. They did their best to reuse every piece they could, including building the bar out of the wood from the walls recently torn down.

The fire pole still sits at the front of the taproom, in between the two faux garage doors. Tables were built from ash, the same wood used for most baseball bats. Vintage baseball art lines the walls, including many pieces that depict the Detroit Tigers, a passion of the owners since they were young. Part of the reason for opening the Mitten Brewing Co. was to be the home of Grand Rapids Tigers fans. It was a fitting name for both baseball and the state of Michigan.

"We want this place to be known as the place in town to go watch the Tigers," Andrus told the *Grand Rapids Press* prior to opening.

Andrus and Trierweiler brought on former Hideout Brewing Co. brewer Wob Wanhatalo to man the three-barrel electric system.

The Tigers-themed bar was gifted with a perfect time to open, and Trierweiler and Andrus rushed to open for the Detroit Tigers'

appearance in the 2012 World Series. Detroit was swept in four games, but the Mitten Brewing Co. won over plenty of customers during its soft opening before closing to recuperate a lost beer supply. Since it rushed to open, only three beers were on tap at the time: Peanuts & Crackerjack Porter, a hefeweizen and a pale ale. Since reopening on November 16, 2012, the portfolio has been rounded out, including what some say is the best IPA in Michigan, Country Strong IPA, and other staples, such as Triple Crown Brown, Vanilla Milk Stout, Stretch Cream Ale and Black Betsy Coffee Stout. By the end of 2012, award-winning homebrewer Jason Warnes was added to the brew team and helped take the brewery to another level.

Pizza recipe development was of almost equal importance to beer, despite expectations it wouldn't sell as well. Through the first year, pizza was selling nearly as well as the beer.

The opening meant Mitten was the first brewery on the west side of the Grand River since Prohibition, in an area that had a bad reputation in recent history. The whole area is getting a revamped look, thanks in part to the Mitten on Leonard Street, which has attracted two businesses on the same intersection since opening, Long Road Distillers and Two Scotts Barbecue.

Andrus and Trierweiler continue to rework their business to give back to the community. Since it opened, the Mitten has paired with a different nonprofit every month and raised more than $32,000 for charity in its first year in business.

Not even open a year, the demand was already driving upward. *MLive* entertainment writer John Gonzalez named the brewery the best new brewery and a can't-miss pizza spot in his statewide searches. The great beer, pizza and reputation led to beers constantly running out and often wall-to-wall crowds. An expansion was needed. For taproom space, the ownership pair returned to rehab the upstairs of the firehouse, the former crew quarters. Brewing, however, was another story. In the first year, Mitten was already hitting maximum capacity of about 600 barrels. A lease was signed for warehouse space across Leonard Street, and a 20-barrel system from JV Northwest was purchased with the potential to scale up to 10,000 barrels a year, with 1,500 in the first year.

The initial brews on the new system were Triple Crown Brown and Country Strong. A canning line was planned for year two of the production space, which began operation in the fall of 2014.

Mitten Brewing Co. installed a twenty-barrel brewhouse in 2014 across the street from the Engine House No. 9 taproom. *Courtesy Mitten Brewing Co.*

"Our first and primary goal at this time is satisfying the taproom demand," Andrus said. "From there, we'll grow as far as quality control will allow, both in beer and customer service.

WINERY TURNS TO BEER

Bob Bonga was making wine in his retail spot near the Gerald R. Ford International Airport, and he realized he needed to have a mix of products to hit a broader market. Bonga wanted the ability to attract a husband-and-wife tandem who might like different types of drinks.

The winery started as a hobby. Bonga was sick of working for the man at Amway, so he branched off and started Cascade Winery. Eventually, he realized a wife coming in for wine often dragged a husband along who might want a beer. So he started Jaden James Brewery, running out of the winery.

He has kept the operation low-key but with a variety of beers on tap from light cream ales to Russian Imperial Stouts. There is something for everyone, he said.

COFFEE TURNS TO BEER

Feeling the surging beer culture around them, the owners of Caledonia coffee shop Essential Bean decided to offer a new beverage. In 2013, the coffee shop rebranded as EB Coffee & Pub and brought aboard a brewer and a three-barrel system to offer the community both morning and evening drinks.

"I want it to be an efficient business," Essential Bean owner Justin Nichols told the *Grand Rapids Press* in 2013. He purchased the coffee shop in 2010. "I'd love it to be a place someone stops at in the morning and on the way home for a pint after work."

Early in the pub's existence, Drew Koszulinski was the head brewer but left within a year.

SERVING FROM THE BOTTOM

Matt Michiels spent quite a bit of time getting to know the craft beer industry in Seattle, Washington, as an auditor before moving back to Michigan.

Fourteen years of homebrewing led Michiels to his next career move, one he had contemplated for several years, a combined brewery and homebrew supply store: Gravel Bottom Craft Brewery & Supply in the village of Ada.

"Ada really feels like it's a nice, tight-knit community," he told the *Grand Rapids Press* in 2013. "It's got a good business community and it's where we live. I want to be able to ride my bike to work."

Michiels brews various types of beer on a three-barrel system that are served on tap, plus a rotating guest tap with area homebrewers contributing recipes. Meanwhile, hops and grain—and a variety of other homebrew necessities—can be purchased on site as well.

Serving the community and its brewers is his goal. "We're not trying to become the next Founders or Perrin," Michiels told the *Grand Rapids Press*. "We don't have ambitions to get huge. We want to have a fun, small local following."

BEER CELLAR

In 2012, a Craigslist ad showed up that took the growing craft beer scene by surprise. With breweries popping up everywhere, many trying to open while undercapitalized, a brewery in Sparta, Michigan, was for sale.

The Michigan Beer Cellar was founded in 2010 by Dan Humphrey, who had been homebrewing for thirteen years. For more than two years, Humphrey made beer on a 5-barrel system and distilled some spirits. But his health wasn't the greatest, and he knew he had to take a step back, so he put it up for sale. Humphrey's son, Nick, had recently been part of an ownership partnership that bought the Hideout Brewing Co. Humphrey had said he worked many sixteen-hour days for three years, including brewing 370 barrels of beer in 2011.

On March 8, 2013, Chuck Brown finalized the $540,000 purchase of the business with Humphrey, which included the transfer of microbrewers', micro-distillers' and small winemakers' licenses. Humphrey's installation of the still for spirits made it the first Kent County distillery since Prohibition.

To take over, Brown left his job as a contract food service provider at Grand Valley State University. He told the *Grand Rapids Press* he'd take an "if-it's-not-broke-don't-fix-it" approach, hinting he would keep many of the aspects Humphrey had built into the brewery. His main goal was to establish a larger distribution chain and branding. The branding changed the name to Cellar Brewing Co.

Brown has switched up the label and reinvigorated the brand and continues to grow the company's reputation.

A HIDEOUT

In the 1970s, an odd spot at 3113 Plaza Drive off Plainfield Avenue opened up, a place called Hubba Tubba. The business was a cross between a hot tub rental facility and a health spa. In 2001, Hair of the Frog opened up as a homebrew kitchen, where homebrewers could come and brew their recipes on a bigger system. Hair of the Frog also operated as a normal microbrewery for a time, but little is available on the history of the business.

Hair of the Frog wasn't long for the world, and in 2005, Ken McPhail and his wife, Laura, bought the brewery and in turn received a virtually fully operational brewery. McPhail had a long pedigree of brewing, starting at Western Michigan University and then following that with his stint as manager of the Bell's Brewery homebrew store. He then moved on to brew at the Grand Rapids brewpub location of Gaylord's Big Buck Brewery for the two years it was in town from 2001 to 2003.

The name Hideout comes from the brewery's unassuming location and its difficulty to find, as well as McPhail's interest in Prohibition. He improved the original Hair of the Frog five-barrel system into a more efficient system for production scale and developed recipes for beers still produced at the location, including Smuggler's Hazelnut Stout, Purple Gang Pilsner and Gangster IPA. He also developed a mead and cider program. With McPhail at the helm, the brewery attracted and maintained a dedicated following of regulars who liked the privacy and coziness of the brewery. Under McPhail's tutelage, two other major names in the BeerCity community—Wob Wanhatalo and Amanda Geiger—developed their brewing skills.

In 2012, Scott Colson and Nick Humphrey took over the company from McPhail, expanding the taproom to thirty-two tap handles and greatly expanding the company's distribution footprint.

"We were having growing pains, and we weren't comfortable expanding," Ken McPhail told the *Grand Rapids Press* in 2012.

The brewery now operates on a ten-barrel system compiled of salvaged tanks, with fermentation done in fifty-five-gallon drums. The pair hopes to eventually scale the brewery up to six thousand barrels a year.

"We're hoping to keep everything about the tap room and really just expand into distributing," Humphrey told the *Grand Rapids Press* in 2012. "We want to distribute and bottle a lot of beer."

Since Humphrey and Colson took over operations, distribution of Hideout beer has gone statewide and continues to grow.

COMMUNITY ROCK

Rockford, Michigan, is a close-knit community, and Seth Rivard, Brian Dews and Jeff Sheehan realized that as they prepared to open Rockford Brewing Co. in 2012.

To celebrate Rockford, the Wednesday before Thanksgiving that year, they threw a pub crawl that placed their beers at bars across the town before the brewery even opened.

"We're really excited about our beers, and we want people from the surrounding area to not only try our beers but come and see Rockford as well," Rivard said. "We want people to get excited about the town and to introduce the places that will be hosting our beers."

Rockford Brewing Co. opened a month later, on December 20, 2012, at 12 East Bridge Street. The brewery opened with a powerful Rockford connection, as Dews was mayor. The three owners were paired up when Sheehan read an article in which Dews said Rockford was missing a brewery. Rivard was looking for brewery real estate when he called the city manager, who informed him of Dews and Sheehan's plans. The three owners felt that Rockford, which sees a lot of tourists, should have a local brewery, and visitors should drink beer made in Rockford, just like pubs in England.

Sheehan does the brewing and was a brewer at New Holland Brewing Co. prior to the opening of Rockford Brewing Co. He runs the brewhouse, which includes a seven-barrel brew system with several seven-barrel and fourteen-barrel fermenters. Beers brewed by Sheehan include Sumatra Porter, Rockford Country Ale, Little George Double

Rockford Brewing Co.'s interior looks rustic and much older than the year it opened brand-new: 2012. *Photo by Damon Card.*

IPA, Paradigm Michigan Pale Ale, Hoplust IPA, Rogue River Brown and Sheehan's Irish Stout.

With Rockford comes a center of outdoor activity, and the brewery has capitalized on the market.

"I've found you inevitably attract those types to a brewery," Sheehan said. "They find you and we're right in the middle of it, and I think Rockford will really embrace it."

Rockford Brewing Co. truly serves as a community center. The brewery's second story acts as a beer hall, with huge communal tables, and it hosts music most nights of the week.

A Long Time Coming

Many brewers stumble into the problem of announcing their existence far too soon. Then come inevitable delays and roadblocks that frustrate owners and potential customers for months following the projected opening date.

Elk Brewing Company's delay lasted much longer than most others. The brewery announced its intentions to open on Wealthy Street in 2011, and a sign read "Coming Soon/Elk Brewing," with the brewery's future logo of an antlered beer bottle.

That sign stood as a reminder to the many owners, homebrewers and beer fans of Grand Rapids that making the switch to making beer for a living is no easy task. It took several hurdles for Eric Karns to open his brewery on May 2, 2014, at 700 Wealthy Street. Elk Brewing marked a big jump in the Grand Rapids industry, as it was the first brewery to open within the Grand Rapids city limits since Grand Rapids Brewing Company in December 2012.

Karns's journey took Elk from three original partners down to a solo operation desperate for help, until his brother-in-law Taylor Carroll joined the mission. Together, they found enough funding to finish the brewery. Private and bank financing helped contribute to the roughly $300,000 startup costs.

Because of a backup at the state level that delayed granting of the liquor license, Elk Brewing Co. was able to brew thirty-five batches

of beer before it opened, all of it done on a three-barrel system from Greenville's PsychoBrew. The brewery opened with an IPA, Black IPA, ESB, Porter and Scotch Ale but has since added several brews, including a hefeweizen and light ale.

The brewery brands with a lot of antlers, but the name comes from a much simpler place: it is the initials of Eric and his wife, Lisa.

Chapter 19
ALONG CHICAGO DRIVE

Prohibition persisted a lot longer in some West Michigan communities, even after the passage of the Twenty-first Amendment. In Hudsonville, about twenty minutes west of Grand Rapids, the ban on alcohol lasted all the way until 2007. Only three businesses had on-site consumption licenses following the overturning of the ban.

The town didn't last a lot longer without a brewery, as a seventeen-month unemployment spell led Bill White to take desperate measures. He had been brewing since his college days at Michigan State University and decided to make a go of it just as the industry was getting its major legs in 2011, using his 401(k) to start up his brewery.

The former construction manager decided it was time and signed a lease for a five-thousand-square-foot warehouse right on Chicago Drive in Hudsonville. His wife, Jenn, is a researcher at Van Andel Institute in Grand Rapids and a major supporter of her husband, often turning in shifts behind the bar. She even lends her nickname, "Flame," to the name of the brewery.

White Flame Brewing Company opened on January 28, 2012, at the time fully brewed and operated by Bill White, an incredibly nice man who will go out of his way to learn your name and get to know you. He can also put beers back with the best of them. His beers run the gamut, including his two flagship IPAs: Super G IPA and Black Sheep black IPA.

His crowd is an eclectic mix of drinkers as well. Some come because they like craft beer, while others just seek a place for a beer nearby work or home. Either way, it's a neighborhood drinking hole run by just another guy.

Hudsonville, a small town of a little more than seven thousand, didn't have just one brewery for long. Less than six months following White Flame's opening, Hudsonville Winery expanded its offerings to include a brewery: Pike 51. The operation sits just several doors down on Chicago Avenue from White Flame.

Winery owners Steve Guikema and Ron Snider chatted about opening a brewery in the 1990s, only to open a winery in 2009. The brewery was, however, in the five-year plan when they opened. But success and local and personal passion for craft beer moved the brewery up a few years with a capitalization of $400,000, including a three-and-a-half-barrel brew system, three fermenters and three brite tanks.

With a new operation in house, they named it Pike 51 Brewing Co. in honor of Chicago Drive, which at one time in history was called Turnpike 51. Pike 51 has brewers Jeff Williams and Amanda Geiger to keep sixteen beers on tap, including Kush IPA and Pants Cream Ale—Pants being Geiger's nickname. Williams moved to Pike 51 from HopCat when the brewery opened, since his family's house is just three blocks away. A light American lager, aptly named Tall Boy, also finds its way onto the tap list.

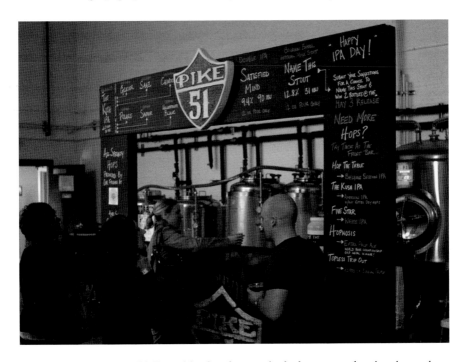

Pike 51 hosts an annual IPA Day with a booth set up in the brewery and various hopped Kush IPAs for tastes. *Photo by Damon Card.*

A little closer to Grand Rapids on Chicago Drive, in Grandville, another brewery, Osgood Brewing Co., opened on September 5, 2013, with appearances by both the Stanley Cup and the Calder Cup a few days later. The brewery is named after Grandville's first tavern, the Osgood Tavern, which was opened in 1837 by Kent County's first district attorney, Hiram Osgood.

Grandville High School teacher Ron Denning had been working on his brewery for more than a year by the time he was able to open it in an old Elder Appliance store. He continues to work as a teacher but decided the brewery was worth pursuing, as he was an avid homebrewer and supported the city's goal of having an improved corridor along Chicago Drive.

Osgood Brewing Co. brews on a ten-barrel system with several seven-barrel fermenters under the supervision of head brewer Thomas Payne. Several of Osgood's brews also pay tribute to history, such as the Oakestown Amber Ale, named to honor the city's first name and its father, Charles Oakes. Other mainstays include Sol Seeker American Wheat Ale, 358 American Pale Ale, Journey IPA, Notley Porter and Big Spring Stout.

The food menu also showcases many daily specials created by Garrett Stover.

White Flame, Pike 51 and Osgood line the route to Holland, but they also represent a larger trend of breweries popping up and supporting communities looking to drink a product made closer to home.

Part V

Lakeshore Booms

HOLLAND

New Holland led the craft beer wave on the coast, growing substantially since its opening in 1997 and growing to the second-largest brewery in the Grand Rapids metropolitan area.

Holland would last about fifteen years with just one brewery before another settled into Tulip City. The town is plenty big enough for two breweries, even if they're located a few doors apart. In October 2012, Our Brewing Co. opened at 66 East Eighth Street to extreme demand. In the first weekend, the brewery, which then brewed on a half-barrel system, ran through thirteen kegs in fifteen hours. The second weekend saw five kegs blow in five hours.

The brewery is owned by Trevor Doublestein, who spent more than a decade managing his family's business, Doublestein Builders, following getting his film degree at Chicago's Columbia College; and Dane Sexton, a financial manager in Ada, Michigan. Sexton maintained his day job, Doublestein took control of the day-to-day operations and Ed DeGalan took control of the brewhouse.

By the time the first few weekends were over, Doublestein and Sexton already had upgraded their brewery to a three-barrel system. The small system allows the brewery to create a great number of unique beers, such as a Coconut Porter, Rye Mo Be There, Careless Whisper IPA, Andes Mint Milk Stout, Oatmeal Cookie Ale, She's My Cherry Rye, Peanut Butter Cup Milk Stout, Glazed Donut Cream Ale and Tobacconist Porter, a porter made with tobacco.

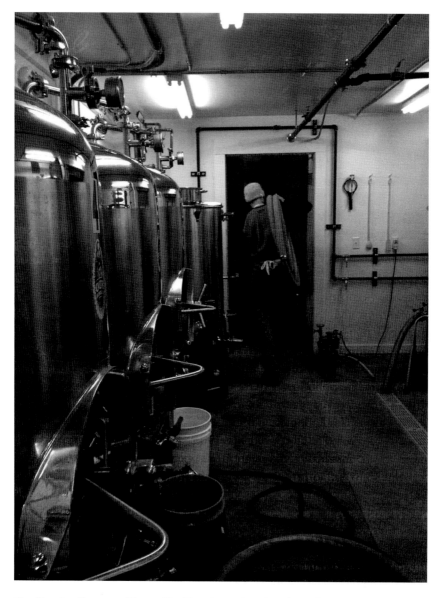

Our Brewing Co. owner Trevor Doublestein carries a hose in the brewhouse beneath the taproom on Eighth Street in Holland. *Courtesy Our Brewing Co.*

It took a couple months for the brewery to catch up and open during the week.

"The demand is growing faster than we thought it would," Doublestein said. "We'll just keep plugging away to meet it. We can only do it in baby steps; we don't have the money to do it all at once."

Having a major Michigan brewery two doors away could be intimidating for some startups, but Our Brewing Co. saw it as an opportunity. Meanwhile, New Holland Brewing Co. president Brett VanderKamp likened the situation to when Starbucks blew up in the 1990s.

"How many coffee shops can you possibly have? We have four in one block," VanderKamp said. "To a certain degree you could have four breweries in four blocks. The limiting factor in distribution will be shelf space, but I don't know if there's a limiting factor in getting people through the door as long as you provide a unique product and atmosphere. They all have their specialties."

Those unique specialties and settings are where Our Brewing Co. gets its name and hopes to excel, by making customers feel at home. Doublestein hopes a long, warm and inviting space with plenty of small-batch brews will take the brewery far. In the fall of 2014, he said he didn't see the brewery expanding anytime soon, as the capital investment and new volume causes many problems.

"We want it to be an intimate, living-room setting, so people can sit for hours to watch games," he said. "We'll have live music. It won't be so restaurant-y or bar-y; it'll be a place to gather."

Just as Our Brewing Co. was starting up, three engineers were preparing their brewery for opening just a few miles away. Gregory MacKeller and Travis Prueter, who work for Gentex Corp., and Nicholas Winsemius, who works for the Grand Haven Board of Light and Power, came together to form Big Lake Brewing Co. in a commercial center on Butternut Drive in Holland Township. All three maintain their day jobs. Prueter had been brewing with Winsemius for several years, while MacKellar made wine. It was a perfect fit.

The brewery opened during the July 4 weekend of 2013, following four years of working on the business. Some issues came up at the state level, but the brewery's landlord helped get the liquor license situation cleared up.

The brewery opened with a three-barrel brew system for beer and made five-gallon wine batches to begin. Quickly, the brewery grew from its two-fermenter, once-a-week brew schedule.

Big Lake Brewing Co. was one of the few breweries that was able to start up without garnering too much attention from the community. And they weren't unhappy with that.

"We hit roadblock after roadblock after roadblock," Winsemius said. "We didn't want to promise anything and not be able to deliver."

The three Holland breweries came together and made a brotherhood of sorts during American Craft Beer Week in 2014. A collaboration beer, an

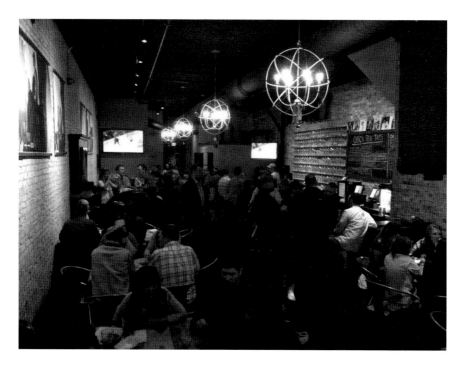

Our Brewing Co. on a busy Friday night in Holland, Michigan. *Courtesy Our Brewing Co.*

English Pub Ale called Our New Lake, was released with a brewery crawl starting at New Holland, heading to Our Brewing and finishing at Big Lake.

"I've been in the brewing business for 18 years," New Holland pub brewer Steve Berthel said in a release for the beer. "The one thing that has remained true since the day I started is the collaborative and inquisitive spirit of those in the industry. This isn't a competition. This is a lifestyle."

CHAPTER 21
GRAND HAVEN

When a family gets a dog, sometimes it means so much that they end up naming a business after it. In 1997, when the first wave of craft breweries started popping up, a brewpub in Spring Lake, Michigan, opened with the name of a beloved chocolate lab. Old Boys' Brewhouse is named after one of the more extravagantly named dogs ever: Brutus the Snake Malone, or Old Boy.

The ten-barrel brewhouse is situated inside the main entrance, and then visitors head through the hall and into a taproom. A lot of normal bar conveniences are in the taproom, such as pool tables and TVs, but instead of the usual decorations, the walls are adorned with a variety of dog-related items. And don't forget the annual Woofstock, a three-day event showcasing dogs. Beers produced include the Old Boys' Brown Ale, Coconut Strong Ale and Magnum Breakfast Stout.

There's limited growth opportunities for Old Boys' because of the brewpub law that allows it to serve liquor but disallows the distribution of the beer.

ROUGHLY THIRTEEN YEARS after the opening of Old Boys', Grand Haven received its second brewery when accountant Chris Michner opened Odd Side Ales, fulfilling a college pipe dream. Michner spent many hours brewing beer in college at Michigan State University and even wrote a homebrewing column for the school's newspaper, the *State News*. So when he lost his accounting job in Grand Rapids in 2009, he and his wife, Alyson,

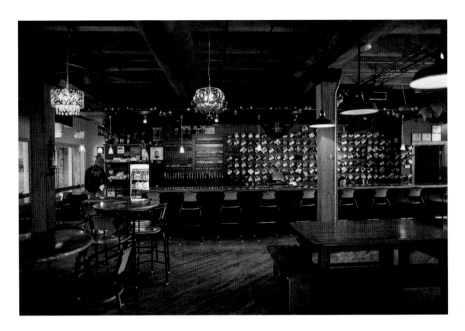

The taproom at Grand Haven's Odd Side Ales is highlighted by the variety of mug club mugs behind the bar. *Photo by Bryan Esler.*

took the chance to open a new business. Odd Side Ales' doors opened in March 2010, and immediately, the brewery started releasing some off-the-wall brews. Michner's regular lineup includes beers such as Mayan Mocha Stout, Pineapple IPA, Java Chip Mint Stout and Watermelon Wheat.

The strange flavors deviating from standard definitions helped grow the brewery into a production facility within two years of opening. A majority of the production moved from the original location at Habourfront Place at 41 Washington Avenue in Grand Haven to a facility at 1811 Hayes Street near the city's airport. In 2013, the brewery started bottling and distributing a great deal of beer. That same year, Odd Side was named as one of ten breweries to watch in 2013 by Food Republic.

CHAPTER 22

MUSKEGON

One of West Michigan's largest cities, Muskegon, was left without a brewery for nearly sixty years following the closure of the Muskegon Brewing Co. in 1957. Finally, in late 2013, the first of three breweries won the race to be Muskegon's first modern beer maker. Unruly Brewing Company opened to an excited Muskegon ready for locally made beer on the Wednesday before Thanksgiving in 2013. Jeff Jacobson, Mark Gongalski and Eric Hoffman spent plenty of time preparing for the company's launch, with Hoffman manning the brew station the month or so before it opened.

A variety of beers fill the tap list from a three-and-a-half-barrel system, such as the Milkman IPA, Revel Rouser IPA, 1890 Cream Ale and Mad Cacao Disease Imperial Chocolate Milk Stout. The cream ale is representative of what many West Michiganders drank prior to Prohibition.

The taproom calls a historic building home at downtown Muskegon's Russell Block Market at 360 West Western Avenue. When embarking on his $2 million renovation of the Russell Block building, building owner Gary Post likely saw a different outcome than a pizza place called Rebel Pies, an artisan coffee shop and Unruly, but the space is full.

A few months later, on March 21, 2014, Pigeon Hill Brewing Co. opened up to another big crowd in downtown Muskegon, just two blocks away from Unruly Brewing. The brewery was opened by three friends, Michael Brower, Chad Doane and Joel Camp. A historical look was chosen by the three partners, and the taproom was filled up by Muskegon's demand that not even Unruly could fill.

"The pent-up demand surged for Unruly, and based on the ongoing support that we have received, we expect the same thing to happen when we open," Brower said before they opened. "It truly is wonderful to feel so embraced by the community."

Pigeon Hill is located in the historic Noble Building, a 1920s car dealership at 500 West Western Avenue. It's now anchoring what is hopefully a large revitalization effort for the downtown block, Brower said. The setting is aided by historical art, tables built from white pine recovered from Muskegon Lake and parts from the old Muskegon Brewing Co. Brower said they found the old grain mill from the 1950s brewery and are restoring it to working order.

"The Noble Building was erected at a time when Muskegon's downtown thrived," he said. "Now, it will be a building block in the revitalization of that same downtown. To us, the Noble Building provides more than an ideal structure—it provides the perfect atmosphere that we seek to embody with Pigeon Hill Brewing Company."

The name, too, is a reflection on history. Pigeon Hill was a massive sand dune in Muskegon during the 1920s and attracted throngs of tourists before the sand was removed sometime before the 1960s.

Beer is of the utmost importance to the Pigeon Hill crew members, and they won't sink to low standards. The first batch of beer they brewed was Walter Blonde Ale, and it didn't come out as planned. They dumped it instead of trying to pass it off as drinkable. Since the dump, however, Pigeon Hill has turned out batches of excellent beer, including LMFAO Stout, Shifting Sands IPA, Jameson Porter and 1762 Russian Imperial Stout.

PART VI
BEER, CIDER AND SPIRITS, OH MY

West Michigan earned a reputation for beer, and from that reputation came two new industry subsets: hard cider and spirits.

The beverages are natural progressions from beer and, despite lagging behind the beer industry, offer a great variety just like beer. For years, beer was thought to be one style: the light American lager made by a few select companies. The microbrew movement changed the way beer was viewed and has helped other liquids break out of standards set by massive companies.

Hard cider is often viewed as a sweet alternative to beer, often flavored with other fruit. With beer continuing to prove its diversity, cider makers in West Michigan have set out to do the same, riding the wave of craft beer paving the way.

Chapter 23
CIDERS

Vander Mill Ciders

Spring Lake's Vander Mill Ciders popped up in 2006 to fill a niche on the lakeshore, which lacked a cider mill for apple cider and doughnuts. Along with providing standard orchard fare, Paul Vander Heide and his brother and sister-in-law, Stu and Christie Vander Heide, also decided to make private label wines and ciders. Seasonal cider and doughnuts weren't enough to help Vander Mill through the tough recession in the late 2000s, so the owners concentrated on the hard cider business to expand their customer base.

Since the release, the company's hard cider has exploded in West Michigan and in more than one hundred Chicago bars and retailers, providing people with a variety of flavors, such as Totally Roasted with cinnamon roasted pecans, Ginger Peach, Blue Gold blueberry and many more. The actual orchard continues to be a destination for families in the fall, with plenty of space for enjoyment.

In 2013, the operation completed a $600,000 expansion, which upped production from 43,000 gallons of hard cider to more than 100,000. It also added a canning line that could package 1,800 cans of cider per hour.

Vander Mill collaborated with New Holland Brewing Co. to make Puff the Magic Cyser, which spent eight months in Dragon's Milk barrels. Vander

Mill takes an innovative look at cider by adding various flavors to the product, like many have done on the craft beer side of the industry.

VIRTUE CIDER

At the helm of his father's brewery, Goose Island Brewing Co., Greg Hall built his name into one of the biggest in the beer industry. Hall's first love was beer, but it's not his only.

When Goose Island was sold in 2011 to Anheuser-Busch for $38.5 million, Greg Hall made a move to open a company to help lead the craft cider movement. His love for the drink stemmed from a night in England in 2000 at a bar hosting a cider festival with forty types of unique ciders. He tried nearly twenty ciders that first night, ranging from sour to funky to sweet to dry to tart. The next day, the group he was with skipped the last brewery tour and went back to have the rest of the ciders.

That night in England helped decide his next step in life, when at forty-five—the same age John Hall was when he started Goose Island—Greg Hall founded Virtue Cider in Fennville, Michigan.

"I told him I was inspired by him to go off and do my own thing," Hall said. "That was to try to bring cider to America the way craft beer has exploded."

Cider makers had popped up across America, but few had made much of an impact outside their local markets. And unlike beer, major companies wanted to stay on the front of a new movement, so Anheuser-Busch, Miller and even Sam Adams bought and started their own lines of cider such as Crispin, Woodchuck and Angry Orchard. The cider market grew 80 percent in 2012, and Hall figured he could help grow it more with his production and marketing background. He went to Europe, learning the various types of cider-making techniques from England, France and Spain.

Once back in the States with a forty-eight-acre farm in southwest Michigan, Hall was free to take cider in a new direction.

"We treat it more like craft beer than other cider makers—this is the case [in Europe], just not in America," Hall said. "[Europeans] worry about the apples. They press the apples, and they don't worry about it until they blend it. They don't have a tradition of having an influence of fermentation; typically, they're fermenting with whatever native yeast is in their orchard or with dry champagne yeast, and those are the only two ways I've seen it made abroad."

Virtue, with head cider maker Ryan Burk, replicates many ciders from across the globe, including apple-forward English, farm-forward French and acidic Spanish. The company also adds its own twist, such as aging cider in whiskey barrels, a trend many brewers now use.

Education is still a priority, since most bars still don't understand the breadth of cider.

"People still have a perception of cider being cider," Hall said. "Bars that have twenty taps will have one cider, and we'll go in and try to sell it, and they say, 'We already have a cider.' That's like saying, 'We already have a beer.'"

Hall could have started his company in many locations, but Michigan resembles many of the other great cider-making regions of the world: coastal, with lots of rain and sun and sandy soil. He's taken to calling the region "the Napa Valley of cider."

He hopes he can continue to build the first national craft cider brand, while fostering a larger community of cider makers around Virtue.

"I felt like there was an opportunity to do something bigger with craft cider," he said. "Then everything started to explode—our timing couldn't have been more fortuitous."

HERITAGE CIDER

Sietsema Orchards has made sweet cider in Ada since 1934, and like several others, Andy Sietsema realized a bigger opportunity for the beverage with craft beer exploding the way it was. With a goal to diversify his product line, Sietsema began making hard cider. He launched with three types: sweet, dry and barrel-aged ciders. Before long, he upgraded his apple press to increase his production to more than eight thousand gallons per year.

Sietsema worked with Greg Hall, Paul Vander Heide and Leelanau's Tandem Cider's Dan Young to help learn the process and educate consumers.

"Their view is they don't want a bottle of crap sitting next to theirs on the shelf," he said. "It's funny, though. It's not the wine community drinking it—it's the beer [community]. But all the wineries are doing it."

His orchard space will help make his ciders unique, as Sietsema wants to plant up to 120 types of apples, including types such as Spitzenburg, which was Thomas Jefferson's favorite apple, Sietsema said.

PEOPLE'S CIDER

When most people think of cider, they think of sprawling acreage and apple trees. Jason Lummen, however, located his cider operation, People's Cider, within the Grand Rapids city limits with the intention of staying there.

He popped up in a small industrial park on Maryland Street between Leonard and Michigan Streets. The small room was lined with ten two-hundred-liter tanks used for fermenting gallons of apple cider from Hills Brothers Orchard. He continues to look for a downtown Grand Rapids taproom location since his initial location on Jefferson Avenue ended up not working out, and right now it appears he's seeking a spot on the west side of Grand Rapids.

Cider brings some difficulties to the table that can be more evident in the beverage than in beer. It's tied to the apple industry and is seasonal, Lummen said. Difficulties come when people expect beer prices for the liquid that takes much longer to make and that is based on an already fairly expensive fruit. Lummen started a cider-making business, however, because the overhead was much lower than for a brewery. He saw the opportunity for a cider maker in Grand Rapids and jumped at it, knowing it could be built into the city's culture.

"There's this perception that the people who drink cider don't like beer," Lummen said. "Beer drinkers will come around to it. It's just the cider they're drinking now isn't good."

CHAPTER 24

DISTILLERIES

As with the rest of the nation, West Michigan saw craft beer first and cider second, both of which continue to grow. Rounding out the beverage industries are the craft distillers that began to pop up in the area in 2014.

Coppercraft Distillery laid its first barrel of whiskey on May 22, 2013, nearly a year before it opened the tasting room at 184 North 120th Avenue in Holland. By the time the whiskey was ready for consumption, the distillery already had released a variety of products, including vodka, citrus vodka, gin and rum, into Michigan, Colorado and Illinois markets.

Co-founder Mark Fellwock said the distilling industry is nearly twenty years behind craft beer but still growing at about 40 percent a year. Fellwock and his partner, Walter Catton, both worked at New Holland Brewing Co. before branching off on their own. The pair invested nearly $1 million in initial equipment and expansion work to secure their distiller's license in 2012. Distillation started with a 300-gallon still to start, but a 750-gallon still was later installed to supplement production. Fellwock said the company will eventually rely on whiskey sales and will be able to lay down more than thirty barrels a month.

Coppercraft has been very collaborative with other Holland companies, such as Our Brewing Co. and Fennville's Virtue Cider. Its tasting room offers customers an inside look while they learn about a new industry dominated by a few major companies.

"We built the space to be unique, with the idea of having the opportunity to celebrate the spirits in this environment every day," Catton said. "When

the tasting room is open, our still is usually running, so you can smell or feel the humidity. It's a cool way to get people introduced to the craft of what we're doing."

IN GRAND RAPIDS, two friends dedicated to the west side of the city were busy in the summer and fall of 2014 readying to open the first distillery in the Grand Rapids city limits. Kyle Van Strien and Jon O'Connor opened Long Road Distillers the following winter. The distillery calls 537 Leonard Street home, right across Quarry Road from Mitten Brewing Co., helping create a hot corner of sorts.

Long Road will go grain-to-glass with all of its spirits, including whiskey, vodka, rum, gin and a variety of other liqueurs. The company will forgo distribution initially to focus on the neighborhood but could see the market in the near future. With the still up and running, Long Road will produce upward of seven thousand twelve-bottle cases annually.

"Founders and Bell's have laid the foundation for the craft brew movement, and now Harmony and the Mitten and other local breweries have really helped bring people's awareness to the local craft alcohol industry, so we think the market is primed for a craft distillery in Grand Rapids," O'Connor told the *Grand Rapids Business Journal* in 2014. "People have a real understanding and appreciation for wanting to know where their products come from and, hopefully, we can capitalize on the knowledge base."

PART VII
SUPPORTING INDUSTRIES

Chapter 25
MORE THAN BEER

A Supporting Crew

With so many breweries in the area, some entrepreneurs are intrigued by the idea of the craft beer industry. Some of them will go on to open breweries or bars, while others have realized the actual beer isn't where the money lies for them.

Dan Slate and Jack Hendon started a CPA company in 1983 in Fremont, Michigan. For years, H&S Companies acquired other CPA firms before it controlled eight offices across the West Michigan region. Eventually, the company added IT and wealth management, but Slate and Hendon decided they wanted to do something they were passionate about. So they decided they could take these skills and apply them to the craft beer industry. So in July 2012, H&S Companies partnered with Muskegon law firm Paramenter O'Toole and Fremont's White Insurance Agency to form a new venture, the Brewers Professional Alliance. The alliance added two more partners in the fall of 2012: Rockford Construction and SWK Technologies.

The partners help offer a variety of services under one banner in hopes of helping the craft beer industry thrive, including accounting, payroll, taxes, IT, insurance, risk management and legal and human resources.

Brewers Professional Alliance hopes to keep all breweries working with a single set of consultants, avoiding competition. One of the main segments is the legal aspect, as the Michigan Liquor Control Commission plays a major

role in nearly every step of a brewery's growth. A lot of the legal issues have to do with beer and the intellectual property behind it but also the industry regulations that are complex and often date from Prohibition.

Startup breweries aren't Brewers Professional Alliance's primary targets. Those upstart companies often don't have the funds to pay for professional consultants and do much of the initial growth on their own. Instead, the consultants look to help breweries looking to expand.

Maltsters

Helping expand business is one thing, but for breweries to grow, they have to produce. With brewery industry growth comes a large opportunity for other local companies to come together and build a supply chain industry to help the breweries produce more local products. The craft beer movement is successful in part because of a larger trend to purchase locally produced products, and the beer industry was one of the largest opponents of that, with several companies dominating the world's supply.

Beer can be made with ingredients from across the globe, but the closer the ingredients are sourced, the fresher and better the beer can be. Of course, this isn't always true, as younger and ill-managed companies can provide subpar ingredients and, in turn, create worse beer. Supply chain companies only can grow with the support of the industry around them, and West Michigan is doing its best to help the craft beer industry spread well beyond the breweries.

Eventually, both the hop and malt industries could be incredibly fruitful paths for people looking to be a part of the craft brewing industry, and several have already started to pop up as the breweries continue to open rapidly. The localized supply chain companies could help provide fresher and cheaper ingredients in the long run.

The lack of local malt was one of the main reasons Erik May decided to enter the market and open Pilot Malt House in 2012, as he and his partner, Paul Schelhaas, were discussing business ideas over a few craft beers. May had spent ten years in the air force. This helped him hone his strategic thinking, which showed there's potential in a company that supports a large and growing industry such as craft beer.

"We wanted to be original and didn't think we had the time and money to start a brewery," May said. "With the limited ingredients in beer and

more hops being grown in Michigan, malt seemed natural. There's a market opportunity. We see a position that we're in a good spot to build."

Aside from Bell's Brewery and a small operation north of Lansing, very little malting was done in Michigan. Even with the opening of Pilot Malt House, there's no way the company can provide anywhere near enough malt for even one brewery to produce its beer with just Michigan malt.

Michigan can grow the main grain used in brewing, two-row barley, but even that crop is lacking. Barley was once a major crop in Michigan, as the state produced more than 300,000 acres' worth of barley. Much of that crop disappeared during Prohibition as one of the crop's major users, breweries, went out of business. Now, the barley grown in the state isn't usable without a quality malter. Most breweries ship in malted grains from Wisconsin and Minnesota, which takes grains grown in the Dakotas and in those states. This can be extremely costly to the Michigan brewers.

Pilot Malt House takes unmalted grain from across the country and increasingly from Michigan to produce its product. The small operation in Jenison, Michigan, produces two-row, six-row, pale, Pilsen, Munich, smoked, caramel, chocolate, black, roasted, rye and wheat malts. Some are organic. Malting is a complex process that sees grains steeped for a period of time until sprouts emerge. Following germination, the grains are roasted for varying times, which helps determine the colors and flavors of the malts. Without the process, the enzymes in grains wouldn't be at optimum levels to help create alcohol.

Breweries have taken a special liking to making wheat beers with Pilot's malt options, as they have begun using Pilot Malt House's malt in limited quantities, including Osgood Brewing Company, Gravel Bottom Craft Brewery and Supply, New Holland Brewing Company, HopCat, Latitude 42, Mitten Brewing Company, Short's Brewing Company, North Peak Brewing Company and White Flame Brewing Company. The malt house also provides malt to local distilleries, including Holland's Coppercraft Distillery.

Pilot Malt House came a long way quickly. In 2013, the company was producing next to nothing, making 3-pound batches in a kitchen. In 2014, Pilot was malting more than 2,300 pounds a week. By the end of 2015, the malt house should be sourcing Michigan-grown barley from nearly one hundred acres of local farms.

GETTING BEER TO CONSUMERS

Sometimes, brothers-in-law have great ideas. Andrew McLean was unhappy with his office life when his in-law decided to show him a segment from a National Public Radio show.

At the time, McLean was interested in the craft beer world but wasn't looking to start an entrepreneurial endeavor, especially a brewery. The article, however, piqued his interest. It profiled "canning factories on wheels." These mobile canning lines were popping up across the country, giving startup and small breweries a chance to can and distribute their beers to places they wouldn't otherwise be able to get into, as canning and bottling lines are expensive pieces of capital. With this knowledge in hand, McLean realized the mobile canning line was an idea with potential to make money, especially in a state like Michigan with more than one hundred breweries, many without the ability to package their brews. McLean called and e-mailed all the companies featured in the NPR story, all west of the Mississippi. Eventually, Colorado Mobile Canning answered McLean's call, with good news: it was starting an affiliate program.

Bad news, though, was that another person in Michigan was interested in the program: Scott Richards. But the pair soon joined together to double their effort and met at Bell's Brewery in Kalamazoo. In that meeting, they realized they were looking to support the craft beer industry, a notion that will help the growing supply chain industries thrive.

"We both wanted to go into it for the same reasons," McLean said. "We didn't just want to make money off the beer movement. We wanted to help the movement."

The pair traveled to Colorado in the summer of 2013 to undergo the weeklong training session with the parent business before driving the fifteen-by twenty-foot box truck back to Michigan. Prior to their training, Michigan Mobile Canning already had its first client lined up, as Right Brain Brewing Co. in Traverse City wanted to use cans in its statewide distribution. The client gave the new company a consistent customer, as it wanted canning every two weeks. McLean and Richards put about $160,000 into the concept, which includes the truck and a Wild Goose Canning Technologies MC-250 system.

The truck travels with blank cans, twelve or sixteen ounces, and sleeve-wraps them with plastic labels approved by the government for the client breweries. Once operational, the mobile canning line fills up to thirty cans

a minute. Running at maximum capacity, the operation can fill more than two million cans a year.

The new option, although relatively expensive, can help give consumers a cheaper and more mobile way of drinking beer. A four-pack of sixteen-ounce cans holds the same amount as a sixty-four-ounce growler but can be retailed for $10.99, instead of upward of $20.00, McLean said. It also gives the consumer a portable package that can go many places and last longer than growlers. Drinkers are quickly realizing the benefits of cans, as more breweries continue the changeover to cans. Cans allow less light and air to touch the product, which lowers the quality. They are also easier to recycle, nicer to the environment and better to transport because of the lighter weight.

Michigan Mobile Canning only has done beer and cider in its early stages, but McLean notes that other beverages are easily canned. He said California companies have started to can wine, and beverages such as teas, sodas and coffees can be canned. The company has worked with Right Brain, Saugatuck Brewing Company, St. Julian Winery, Ann Arbor's Wolverine State Brewing Co. and several breweries in Indiana and Illinois.

Since the company announced its arrival to the state, Michigan has seen a can revolution, led by breweries such as Brewery Vivant that canned beer from the beginning of production. Other major breweries have followed suit, including Founders Brewing Co. and Bell's Brewery, which both installed canning lines to can flagships such as All Day IPA, Centennial IPA, Two Hearted IPA and Oberon.

It took a long time for a majority of the craft beer movement to catch on to the can idea, but since 2012, it's quickly making a move to become the dominant package.

"I thought the stigma against cans would be more," McLean said. "But people know now the benefits of cans over bottles."

Glass Is Still Cool

Shortly after Grand Rapids won its second consecutive BeerCity, USA title in an examiner.com poll, a prominent Grand Rapids manufacturer decided to venture into the beer industry by starting a new division: Beer City Glass.

The company already was screen printing some things for breweries, including growlers, so a simple rebranding to Beer City Glass was a way to market itself better to local breweries, said Beer City Glass marketing manager John Bereza.

With the rebranding, the company also expanded its product offerings. Beyond the simple brown and clear growlers many are familiar with, Beer City Glass also offered colored growlers and a few variations of thirty-two-ounce howlers when it began operation. Before long, however, the company exploded with options. It now offers twenty-six-ounce mini howlers, flip-top growlers, glassware and a variety of stainless-steel growlers. One unique offering is a "Journey Jug," which comes in growler and howler sizes with an option to track the jug's journey online. Stainless steel growlers come in handled, mini keg and cylinder varieties. Beer City Glass also offers brand development and design for breweries and other companies that need help with those services.

The company had more than forty clients early in its existence, including Founders Brewing Co. and Brewery Vivant. The company was officially formed shortly after the state of Michigan passed new growler laws allowing restaurants and bars to fill growlers, a practice that had previously been forbidden.

"It's perfect timing for us," Bereza said in June 2013. "With the new growler laws passed last week, it opens up to bars and restaurants."

The company also offers design and marketing consultation to up-and-coming companies in the sector, from breweries to wineries and distilleries. Beer City Glass helped develop the brand behind Detroit's Valentine Vodka. It also offers in-house services for label, packaging and brochure design.

"The Michigan craft industry is booming," Bereza said. "It gives people an opportunity to get out of the normal industries and allows them to create something they enjoy. We enjoy craft bottle printing, and we get excited about the empty containers."

Part VIII

Beer City's Future

CHAPTER 26
THE FUTURE IS NOW

With Grand Rapids gearing up for a three-peat as BeerCity, USA, Papazian ended the examiner.com poll, explaining he felt it had fulfilled its duty. Grand Rapids ran with his goal and took it further, constantly rallying around neighborhood breweries and making them preferred watering holes while watching Founders Brewing Company continue to build into one of the nation's largest and most-respected breweries. Experience Grand Rapids, an organization marketing the city, uses beer as one of its main subjects to market the city on a nationwide basis.

The poll made the city aware of its growing craft culture, and the population has greatly rallied around it, creating more businesses catering to the demand. Brewers made citywide collaborations, including a pale ale, a pumpkin beer and a beer benefiting local parks with a grove of trees dedicated to the brewers, aptly named Brewers Grove.

Just because beer is huge in Grand Rapids, however, doesn't stop brewers from hearing a question that plagues the industry nationwide: "When's the bubble going to burst?"

Each brewer has his or her own opinion of when the industry will see a shakeout or when growth will flat line. Most of the established brewers are on the same page, saying whatever happens is still a ways off.

One thing is certain, however: breweries producing good beer will have a place to serve their beer. The market is still refining palates, but once enough mouths are discerning, the bad breweries—of which there are plenty nationwide—will begin to disappear. When Founders Brewing Co. and New

Holland Brewing Company started, they had their growing pains, but the market didn't know better. Now, a startup brewery doesn't have the luxury of messing up. There are enough options out there that a consumer can choose a place with great beer.

Regardless, those few initial breweries did a lot to help get Grand Rapids beer where it is now. New Holland Brewing Company and Founders Brewing Co. put in years of work to help set up the future companies.

Brewery Vivant owner and New Holland Brewing co-founder Jason Spaulding said the old guard of breweries, a half dozen or so, would compete for one tap at a restaurant. They knew one another but didn't like their competitiors all that much at first. Then the state's brewers teamed up to start the Michigan Brewers Guild and started the culture Michigan beer fans know and love today.

He said he hopes new breweries understand that at one time, it wasn't easy to go from zero barrels to ten thousand barrels a year. It took both New Holland and Founders nearly ten years before they cracked four thousand barrels a year.

"It helped us work together for a common cause. Now I still have really good relationships with that first wave, because we were all fighting the good fight. Anyone in it wasn't there for a quick buck, [and] that's not always true now," Spaulding said. "There's a close bond that happened there. I cautiously welcome new breweries. They have to prove themselves before I accept them—not that my opinion means anything. It used to be 'Let me help'; now that tide is turning, the competition is ramping up and there are people who probably shouldn't be in it. Do they even know how lucky and awesome it is to grow like they are? There had to be a lot of trench work done to get to where we are now."

BIBLIOGRAPHY

Interviews with the following were conducted by the author specifically for this project, a related previous project or various articles: Chris Andrus, John Bereza, Bob Bonga, Michael Brower, Fred Bueltmann, Walter Catton, Ron Denning, Jacob Derylo, Brian Dews, Thomas Dilley, Trevor Doublestein, Dave Engbers, Mark Fellwock, Greg Hall, Dan Humphrey, Eric Karns, Jason Lummen, Erik May, Andrew McLean, Ken McPhail, Seth Rivard, Dr. Wilheim Seeger, Mark Sellers, Jeff Sheehan, Steve Siciliano, Andy Sietsema, Jason Spaulding, Jarred Sper, Mike Stevens, Max Trierweiler, Brett VanderKamp, Jackson Van Dyke, Wob Wanhatalo, Jason Warnes, Bill White, Nicholas Winsemius.

WORKS CITED

Acitelli, Tom. *The Audacity of Hops: The History of America's Craft Beer Revolution.* Chicago: Chicago Review Press, 2013.

"Alpena." Michigan Shipwreck Research Association RSS. September 24, 2014. http://michiganshipwrecks.org/shipwrecks-2/shipwreck-categories/shipwrecks-lost/alpena.

American Brewers Review 12 (1899). Edited by Dr. R. Wahl and Dr. M. Henius, multiple articles.

Anheuser-Busch. Letter to Burge Chemical Products. In possession of Grand Rapids Public Library, Grand Rapids, Michigan.

Baker, Robert H. *The City of Grand Rapids, Manufacturing Advantages Commercial Importance; Sketches of the Principal Industries and Business Houses.* Grand Rapids, MI: B.F. Conrad, 1889.

Baxter, Albert. *History of the City of Grand Rapids, Michigan (with an Appendix— History of Lowell, Michigan).* New York: Munsell, 1891.

The City of Grand Rapids and Kent County, Mich., up to Date, Containing Biographical Sketches of Prominent and Representative Citizens. Logansport, IN: Bowen, 1900.

Ellison, Garrett. "Ada's New Gravel Bottom Craft Brewery & Supply Store Will Combine Beer Hemispheres." *Grand Rapids Press*, April 14, 2013.

———. "Caledonia's Essential Bean Aims to Be Michigan's First Coffee Shop and Brewery." *Grand Rapids Press*, July 24, 2013.

———. "'Go Big or Go Home': How Randy Perrin Hopes to Make His Mark in Michigan's Craft Beer Industry." *Grand Rapids Press*, September 12, 2012.

———. "Pike 51 Brewery Opening in Hudsonville Represents '20-Year Dream' for Blue-Collar Partners." *Grand Rapids Press*, May 23, 2012.

"*Equitable Trust Co. v. Christ et. al.*" In *Federal Reporter, Cases Argued and Determined in the Circuit Courts of Appeals and Circuit and District Courts of the United States.* Vol. 47. St. Paul, MN: West Publishing Company, 1892.

Fisher, Ernest B. *Grand Rapids and Kent County, Michigan: Historical Account of Their Progress from First Settlement to the Present Time.* Chicago: Robert O. Law, 1918.

Goss, Dwight. *History of Grand Rapids and Its Industries.* Chicago: C.F. Cooper, 1906.

Grand Rapids Community Foundation. "Our Grand Rapids Community Foundation." September 24, 2014. http://www.grfoundation.org/.

Grand Rapids Daily Democrat, April 1867.

Grand Rapids Daily Eagle, January 30, 1881; February 8, 1871; August 6, 1878; August 20, 1870; September 26, 1879; November 4, 1881.

Grand Rapids Daily Leader, April 12, 1880.

Grand Rapids Enquirer and Herald, January 1, 1859; January 3, 1858; July 19, 1859.

Grand Rapids Fire Department. *History: 1844–1899.* Grand Rapids, MI: Cockett & Conklin, 1899.

Grand Rapids Herald, April 25, 1909; September 7, 1952.

Grand Rapids Medical Monthly (1900). http://books.google.com/books?id=0g-gAAAAMAAJ.

Grand Rapids Press. "Aleing Enterprise." February 21, 1998.

———. "Brew Deal." August 24, 2001.

———. "Brewhaha." April 4, 1998.

———. "Brewing Up a Business." March 19, 1998.

———. "Couple Brew Up Business." March 24, 2005.

———. "Downtown Restaurant Bar Closes." June 6, 1999.

———. "Eternal Spring." April 26, 1987.

———. "Hopping Industry." April 10, 1998.

———. "Microbrewery Will Be First for Cascade." January 11, 1997.

———. "New Eatery Hopes to Tap Nationwide Vat of Beer." October 31, 1993.

———. October 11, 1936.

———. "On the Riverfront." April 27, 1997.

———. "Perrin Brewing Co. Lands Nate Walser, Former Founders Head Brewer Who Developed KBS." August 7, 2012.

———. September 9, 1992.

Grand Rapids Progress. "Personal Liberty." June 1922.

Grand Rapids Sunday Morning Herald, September 27, 1914.

Grand Rapids Times, June 1879.

History of Kent County, Michigan; Together with Sketches of Its Cities, Villages and Townships, Educational, Religious, Civil, Military, and Political History; Portraits of Prominent Persons, and Biographies of Representative Citizens. Chicago: Chas. C. Chapman, 1881.

The Industries of the City of Muskegon: With Historical, Descriptive and Biographical Sketches of Its Business and Business Men in 1880. N.p., 1880.

Knoedelseder, William. *Bitter Brew: The Rise and Fall of Anheuser-Busch and America's Kings of Beer.* New York: HarperBusiness, 2012.

Lydens, Z.Z. *The Story of Grand Rapids.* Grand Rapids, MI: Kregel Publications, 1966.

Report in Grand Rapids Public Library Bajema Collection Beer & Breweries.

Seeger, Wilhelm W. "The Braumeisters of Old Grand Rapids." *Grand River Valley Review* 8, no. 1 (1988).

Starner, Lisa Rose. *Grand Rapids Food: A Culinary Revolution.* Charleston, SC: The History Press, 2013.

Vande Bunte, Matt. "Grand Rapids Microbrewery Looking to Spill into Former Hot Tub Hub." *Grand Rapids Press,* January 10, 2012.

Vanderveen, Steve. "Brewing in Holland Started in 1863." *Holland Sentinel,* September 7, 2008.

"West Michigan Breweries Boom." *Grand Rapids Business Journal* 21 (July 2006).

White, Arthur Scott, and George N. Fuller. *History of Kent County.* Dayton, OH: National Historical Association, 1926.

INDEX

A

Aberle, Elias 51
Alpena 24, 33, 169
Andrus, Chris 83, 127, 169
Anheuser-Busch 14, 37,
 38, 39, 44, 61, 62,
 66, 70, 152, 171
Arena Brewing Co. 80, 81

B

Baxter, Albert 19, 20,
 21, 22, 28, 29, 38,
 55, 170
Beer City Glass 163, 164
Bell, Larry 66, 85
Bell's Brewery 15, 80, 85,
 112, 132, 161, 162,
 163
Big Buck Brewery 132
Big Lake Brewing Co. 143
B.O.B.'s Brewery 76, 81
Bonga, Bob 129, 169
Brandt, George 14, 31,
 43, 50
Brewers Professional
 Alliance 159, 160

Brewery Vivant 16, 83,
 85, 86, 108, 110,
 111, 163, 164, 168
Bridge Street 22, 25,
 27, 28, 29, 51, 58,
 62, 133
Bridge Street House 27
Busch, Adolphus 39, 44

C

Canal Street Brewing 13
Christ brothers 27
Christ, Gottlieb 27
Christ, Gustav 28
Cincinnati Brewery 33
City Brewery 21, 31, 51, 71
Coldbrook Brewery 32
Comstock, C.C. 37
Coppercraft Distillery
 155, 161

D

Denning, Ron 138
Derylo, Jacob 83, 108
Dews, Brian 132, 169
Doublestein, Trevor 141

E

Eagle Brewery 35
EB Coffee & Pub 130
Elk Brewing Company 134
Engbers, Dave 13, 14, 85,
 88, 90, 91, 92, 94,
 96, 108, 169
Evangelical Lutheran
 Church of
 Immanuel 22

F

Founders Brewing Co. 13,
 15, 33, 50, 80, 85,
 88, 91, 113, 126,
 163, 164, 167, 168
Frey, John E. 38, 39
Furniture City Brewing
 Company 51, 52,
 56, 61, 62

G

G. and C. Christ 27
Geiger, Amanda 132, 137

Goebel Brewing Co. 62, 67, 70
Goetz, Adolph 14, 33, 43, 45
Gongalski, Mark 147
Grand German Jollification 22
Grand Haven 4, 24, 143, 145, 146
Grand Rapids Brewing Company 14, 43, 44, 45, 46, 47, 48, 49, 50, 51, 61, 62, 64, 65, 67, 69, 70, 75, 76, 80, 81, 85, 112, 113, 114, 115, 116, 134
Grand Rapids Daily Democrat 31, 170
Grand Rapids Daily Enquirer and Herald 27
Grand Rapids Daily Leader 24, 29, 170
Grand Rapids Herald 45, 46, 47, 55, 62, 65, 170
Grand Rapids Rifles 22
Grand Rapids Times 23, 171
Grand Valley Brewing Co. 53
Gravel Bottom Craft Brewery & Supply 130, 170
Guinness 67, 70

H

Hair of the Frog 131, 132
Hall, Greg 152, 153
Harmony Brewing Company 123
Herpolsheimer 31
Hi-Brau Beer 70
Hideout Brewing Co. 127, 131
Hoffman, Eric 147

Holland City News 24, 71
HopCat 15, 16, 113, 116, 117, 118, 119, 137, 161
Hope College 85, 86, 98
Hubba Tubba 131

I

Imperial Brewing Company 62
Ionia Street 21
Isham, Scott 79

J

Jacobson, Jeff 147
Jaden James Brewery 129
Jefferies, Ron 80

K

Karns, Eric 134
Kosmicki, Jeremy 92, 95
Kowalewski, Robert 78
Kowalski, Kim 80
Kusterer Brewing Company 25, 26, 43, 44
Kusterer, Charles F. 25, 44
Kusterer, Christoph 14, 20, 24, 31, 33, 44, 45, 88
Kusterer, Christopher E. 45
Kusterer, Phillip 25

L

Lohman's Ace High Beer 62
Long Road Distillers 128, 156
Lyon, Lucius 54

M

Maine Law 54
McKay, Frank D. 62
McPhail, Ken 131, 132

Meeske, Gustav 67
Michiels, Matt 130
Michigan Brewery 29, 30
Michigan Brewing Co. 62, 63, 64
Michigan Mobile Canning 162, 163
Michner, Chris 145
Mitten Brewing Co. 11, 34, 83, 127, 128, 156
Mull, Alec 80
Muskegon Brewing Co. 37, 62, 67, 70, 147, 148

N

New Holland Brewing Co. 85, 86, 98, 101, 105, 133, 143, 151, 155, 168
Ninnemann, Gottlieb 67
Nu-Bru 56

O

Oak Hill Cemetery 24
Odd Side Ales 145, 146
Old Boys' Brewhouse 145
Old Kent Products Co. Brewery 62
Osgood Brewing Co. 138
Our Brewing Co. 141, 142, 143, 144, 155

P

Pabst Brewing Co. 14
Palmer, Gabi 122
Pannell, John 14, 19, 20, 21
Pantlind Hotel 33, 57
People's Cider 154
Perrin Brewing Co. 126, 171
Perrin, Randy 124, 170
Peter Fox Brewing Company 64